BRITISH MODERN

STEVEN HELLER

GRAPHIC DESIGN

BRITISH

CHRONICLE BOOKS

AND LOUISE FILI

69(076)

MODERN

BETWEEN THE WARS

SAN FRANCISCO

The authors are very grateful to Rebecca Holzman, our researcher, for her tireless detective work. Thanks also goes to Mary Jane Callister of Louise Fili Ltd., for her design and production expertise. As usual much gratitude goes to our colleagues at Chronicle Books: editor, Bill LeBlond; associate editor, Lesley Bruynesteyn; art director, Michael Carabetta; and design coordinator, Julia Flagg. And last but not least our agent, Sarah Jane Freymann.

We are also indebted to those whose collections we raided for this book, notably Robert Opie, who supplied the lion's share of the materials. Also thanks to Kurt Thaler, Catherine Bürer, Barbara Meili, and B. Hausmann at the Plakatsammlung Museum für Gestaltung Zürich; The London Transport Museum; Irving Oaklander Books; and Steven Guarnaccia.

CREDITS

Unless otherwise noted below the material in this book comes from private collections. Robert Opie Collection: 11, 19–21, 24–25, 27–30, 32 (bottom left and right), 33–34, 38, 40–47, 50–51, 52 (left), 53–55, 56 (bottom left, top right), 57, 73, 74 (bottom left), 75 (left), 76, 77, 78 (bottom), 79 (bottom and top right), 80 (left), 82–84, 86, 87 (bottom left and right), 89 (bottom left and right), 91–94, 95 (top right), 96 (middle), 99, 101, 102 (top left, right and middle), 103, 104, 105 (top right), 106–107, 109, 110 (bottom left and right), 111–113, 116 (bottom), 117 (bottom left and right, top right), 118 (bottom left and right), 119–120, 121 (bottom), 123, 125, 130. The Wolfsonian Collection, Miami, Florida: 35, 56 (bottom right), 118 (top), 121 (top left), 122. The London Transport Museum: 59–71. Plakatsammlung Museum für Gestaltung Zürich: 81, 115, 121 (top right). Steven Guarnaccia: 96–97 (razor blade packages).

Book design by Louise Fili and Mary Jane Callister.

Printed in Hong Kong. Library of Congress Cataloging-in-Publication Data: Heller, Steven. British Modern: graphic design between the wars / Steven Heller and Louise Fili. p. cm. Includes bibliographic references. ISBN 0-8118-1311-8 (pbk.) 1. Commercial art—Great Britain—Themes, motives—Catalogs. 2. Modernism (Art)—Great Britain—Catalogs. I. Fili, Louise. II. Title. NC998.6 G7H45 1998 97-26250 741.6 0941—dc21 CIP. Distributed in Canada by Raincoast Books, 8680 Cambie Street, Vancouver, B.C. V6P 6M9 10 9 8 7 6 5 4 3 2 1 Chronicle Books, 85 Second Street, San Francisco, California 94105. Web Site: www.chronbooks.com

I N T R O D U C T I O N

"There is a healthy stimulus in change, whether of air, scene, or in the crafts of advertising and printing."
—R. P. GOSSOP, 1935

England, the birthplace of the industrial revolution in the nineteenth century and the most commercialized Western nation in the early twentieth, was reluctant to accept modernism as a means to package and advertise its industrial and consumable products. During the early 1920s Britain's commercial trade organizations stubbornly rejected stylish trends and foreign fashions. Modern graphic design—the visual code of progress, which represented a shift from decorative ornamentation to economical functionality—was born on the Continent and therefore viewed as anathema to British taste. Although Germany and France had abandoned old-fashioned advertising techniques after World War I in their struggle to regain economic equilibrium, England clung to its late nineteenth century graphic arts tradition as though holding on to a precious piece of its empire.

There was a right way, a wrong way, and more important, an English way to promote British wares. This was based on the assumption that consumers were conservative and unwilling to tolerate change. Advertising and packaging had to be tasteful and elegant. Classic typefaces, decorative ornaments, and realistic renderings were encouraged. And advertising executives repeatedly told their graphic artists: "We must give the public what it wants," a dictum that absolved designers from the sin of mediocrity.

The keepers of the traditional flame further criticized the few intrepid modern designers then practicing in England for forcing their principles into advertising at the expense of the advertiser. "The public were so interested in the posters as pictures that they largely forgot their message as posters," wrote

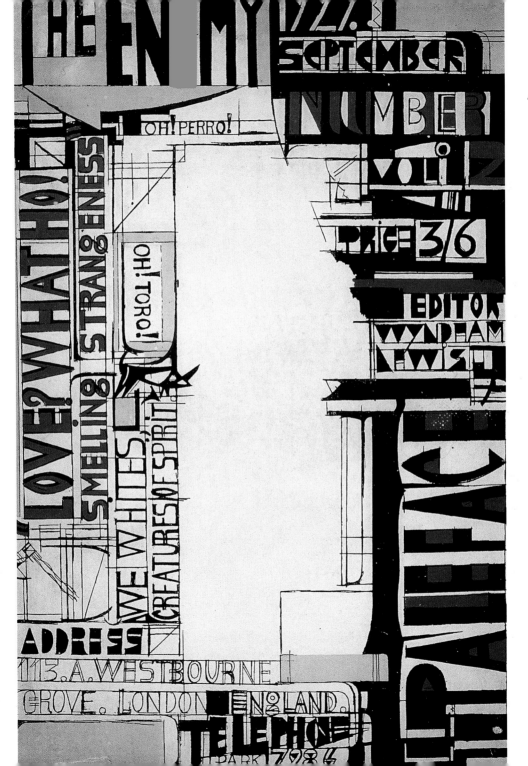

THE ENEMY
MAGAZINE
COVER, 1927
ARTIST: WYNDHAM
LEWIS

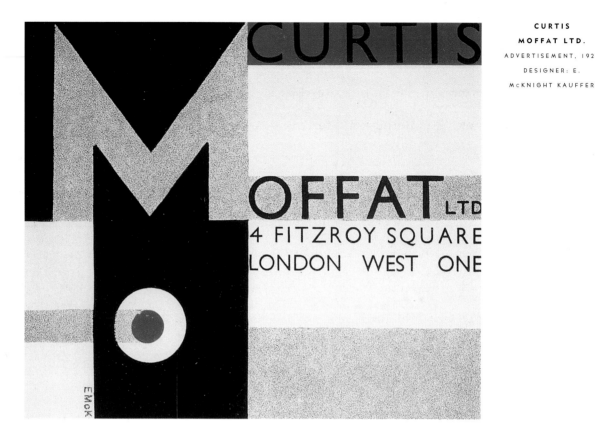

CURTIS
MOFFAT LTD.
ADVERTISEMENT, 1928
DESIGNER: E.
McKNIGHT KAUFFER

one critic about the modern preference for dynamic abstraction. And in an article in *The Penrose Annual* (1935) on the initial impact of modern art on English publicity, poster artist R. P. Gossop, himself a modernist, described the prejudice of critics during the early 1920s: "Simple design was defined as 'modern' only because of its simplicity" and "Angularity of treatment was dismissed in a word for some years; the word was 'futuristic'...."

On the Continent, by the early 1920s France, Italy, Holland, and Germany had introduced their own variants of this "futuristic" graphic style alternately known as modern, moderne, modernistic, or Art Deco (as it is referred to today), which relied on dynamism, asymmetry, and surprise to convey mes-

sages. Rather than a pox on popular taste, as the English had feared, modernism symbolized the post-war shift to a revitalized peacetime economy.

France and Germany made impressive showings at the 1925 Paris Exposition des Arts Décoratifs & Industriels Modernes, the international festival of commercial style that officially launched—and gave its name to—the Art Deco epoch. The trade boards and economic ministries of these nations reasoned that modernity could jump-start the moribund post-war engine of commerce by giving consumers the impression of progress—of "new and improvedness." Meanwhile, England rigidly stuck to austerity in the face of Continental flamboyance. As Carol Hogben wrote in *British Art and Design 1900–1960* (Victoria and Albert Museum, 1983), "Our showing in 1925 was half-hearted in the extreme. The French government's own official report commented that in point of physical scale our participation was worthy of our economic importance. But from the artistic point of view, it did not offer the revelations expected from a country which had been the birthplace of the revolution against ugliness and pastiche, and in which the marvelous example, from the 19th century, of our Ruskins, our William Morrises and Walter Cranes had revitalized the art of their age." At the time even the British government's own white paper admitted the overall impression of their exhibits was "dull, aloof, lacking in the spirit of adventure."

Yet British design was not always this lackluster. During the 1890s Aubrey Beardsley broke the academic stranglehold over poster design with his eccentric, chiaroscuro renderings of fanciful, post-pre-Raphaelite characters. At the same time, the Beggarstaff Brothers—James Pryde and William Nicholson—created a new approach to poster art that was resolutely modern. Although the Beggarstaffs did not have much commercial success, the poster maquettes they used to show as samples, using silhouettes

composed of pure, flat tints and complemented with minimal, bold lettering, were reproduced in various trade journals. They were a source of inspiration for the "pictorial placard" that came into its own in England during the mid-1920s. The Beggarstaffs also influenced leading German poster artists—especially the members of the Berliner Plakat movement—who in the early 1900s fostered an advertising style that was described in *Design in Modern Printing: The Year Book of the Design and Industries Association* (Ernest Benn Ltd, 1928) as having "movement and colour, a decorative exuberance which makes them very lively and pleasant things."

The widespread acceptance of this method on the Continent, and its subsequent promotion in European graphic arts trade journals, inspired young English designers to further the quest for modernity. But lacking viable clients at home, modern British designers were forced to sell their designs abroad, mostly to German advertising agencies and printers, who paradoxically sold usage rights back to English companies who were willing to experiment with the new forms. It was a circuitous route, but ultimately, modern design won out and found champions within the influential design organizations and trade groups. The Design and Industries Association mediated between those members who preferred to maintain the handicrafts tradition and others who sought to raise the standard of design in mass-produced and "machine-begotten" objects of common use. The Empire Marketing Board, which represented and dictated trade preferences to many of England's manufacturers, also stood behind what one of their leaflets called "the admirable simplifications of our accomplished poster artists [who create] not modernist eccentricities but essentially intelligent adaptations [to achieve a] means to an end."

The "end" referred to was the goal of attaining widespread increases in British trade throughout the empire and the world. By the mid-1920s British industry was facing a slump at home and fierce com-

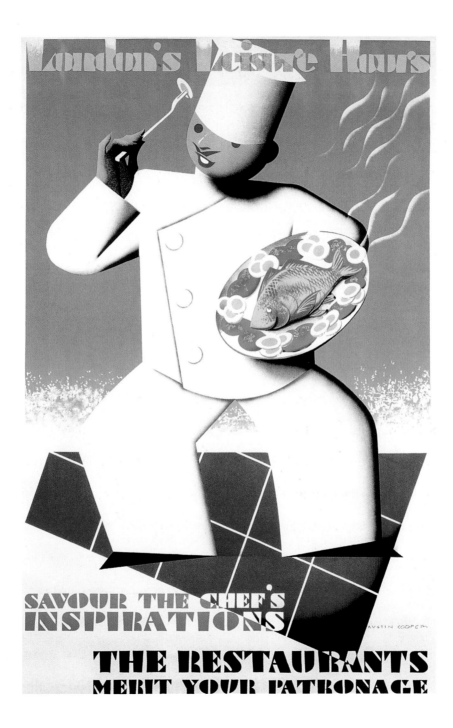

**LONDON'S
LEISURE**

POSTER, C. 1932
ARTIST: AUSTIN
COOPER

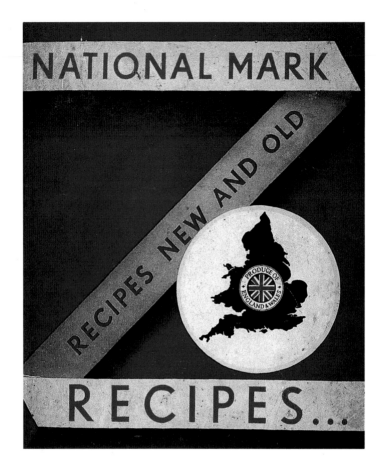

petition abroad. Much was written in the design trade journals about marshaling progressive graphic

design to combat this threat, particularly the resurgence of German trade in the post-war era. Despite

the fact that the devastation of World War I had temporarily paralyzed German industry, an editorial in

a 1924 issue of England's *Commercial Art* magazine anticipated its inevitable recovery and ensuing

competition. Germany was in the midst of a tremendous spiritual awakening, warned the editorial:

"... German laboratories and art centers are enthusiastic and active and preparing for the day of recov-

ery." Against this fervent German impulse the commercial art movement in England was unimpressive.

So the editorial further cautioned: "It behooves us to emulate the Germans in the attention they pay to laboratory and studio work, for only by these means will we be able to keep pace with our rivals ..."

The critics of stodgy British advertising also saw America as a worthy opponent: "Why is it that our standard of commercial art does not approach that of the Americans," asked Brian Rowe in "Commercial Art in England and America: A Difference in Attitude" (*Commercial Art*, 1924). He blamed it in part on the nonexistence in England of "a breed of men called art directors," which he described as Renaissance men of advertising who controlled both image and text to accomplish a creative end. But despite his awe of American practice, Rowe concluded that "We can show them infinitely more progress since the war than they have made We can show them ... modernity [that] they have not the wit or courage to use."

Rowe sounded a clarion call for members of a new generation of "modern artists for industry," including Austin Cooper, Tom Purvis, and the American expatriot Edward McKnight Kauffer, who in the face of prevailing conservatism produced sophisticated—and progressive—graphic design that was wedded to the avant-garde languages of Cubism, Futurism, and Vorticism. Through their efforts modernism gradually found a niche. Outlets for this work became more common. Each of these artists, in fact, was the beneficiary of a far-sighted patron, Frank Pick, who from 1908 to 1940 directed publicity respectively for the Underground and London Passenger Transport Board. In the early teens he was instrumental in developing an identity and publicity campaign for The Underground, which evolved into the British poster renaissance of the late 1920s. Pick reasoned that to entice its passengers the Underground and its bus service not only had to provide clean, comfortable, and efficient transport, it had to promote its services in an artistic manner—even the maps required a creative touch. Pick's

poster campaign gave the people of London a virtual picture gallery, which John Harrison in *Posters and Publicity: Fine Printing and Design* (The Studio, Ltd., 1927) proclaimed was "[A]s fine in some ways it seems to me as the Tate or the National [Galleries] and with much more imposing numbers of visitors." He continued by saying that Pick "has made possible by enlightened patronage the admirable work of the modernist advertising designers who would otherwise have starved."

By the mid-1920s the Underground, British Railway, and English travel posters in general began winning recognition in international advertising competitions and exhibitions. Upon the heels of this success the trade journals were quick to announce that "England was leading the way." But as if to qualify their approbatory articles, many stated that the new generation of posters and advertisements were characterized by a "style of refined modernism" wherein the lettering is "effective without being eccentric." Despite the apparent popular approval of avant-gardisms born of European art movements, the design critics believed that strict British composure had to be maintained.

One critic described the new British accent in graphic design as "old English-modernism." He was referring to how British taste had adapted to the new visual vocabulary and reconciled itself to what he referred to as "conflicting emotions aroused by modern art." These debates centered around the triumph of beauty over ugliness and, more importantly, national pride over international assimilation. Germany was the "inspirational country of modernism and they show very clearly how the grotesque may very easily degenerate into the merely unpleasant," argued an editorial in *Commercial Art* (1918). Under no circumstances did English critics want to succumb to foreign design domination, especially by their former enemy. But the *Commercial Art* editorial did acknowledge the reason for England's gradual adoption of what had become an international style: "The wireless and Cook's Tours have produced an

extraordinary similarity between us all, and there is little to distinguish one capital from another, except language. We in England cannot afford to ignore what other people are doing unless we want our trade to go the way of our sport championships."

A fragile trade balance ultimately dictated the look of advertising art. And it was the job of England's agencies (or art departments for industry) to put modernism to effective use. Among the most prominent firms were the Carlton Studios, the Basset Gray Studios, the Crichton Studios, and the Clement Dane Studios. But of them all, Crawford's was the top agency and a leading proponent of pictorial modernism. Ashley Havinden (known as Ashley) was one of Crawford's most accomplished staff designers, who through his newspaper ads and posters helped define English graphic modernity. "...[I]n Ashley's work there is a feeling of newness hard to define," wrote poster artist Horace Taylor in *Commercial Art* (1932). "He does not seem to be so much concerned with making his space look dignified or distinguished as with getting the advertisement read." With this in mind, Ashley introduced novel typefaces that embodied the modern spirit (and that were always associated with Crawford's), including Maximilian, Neuland, and Semisat. He often set the lettering in a swerve on a curve, which helped bust the timeworn tenet of maintaining central axis composition. Taylor noted that "the pull of these advertisements is flatteringly indicated by the vast number of imitators."

The critical mass of modern designers and new outlets got the public used to the new design. But the 1927 Advertising Exhibition held at Olympia was truly the turning point. As if to make up for England's pitiful showing at the 1925 Paris exposition, this massive undertaking, organized by the Advertising Association, was an exuberant celebration of modern and modernistic graphic techniques. The huge exhibit hall was a veritable carnival of modernistic displays. And advertisers who were still

skeptical about the value of modern art were seduced by design that incorporated simple symbolism and strong colors. Design that jumped off the poster hoardings drew attention to the message, which quantifiably sold more goods. As a result, by the early 1930s modernism was common in English advertising and package design.

Predictably, however, success fostered rampant imitation, excess, and abuse, which prompted a critical backlash in the contentious trade press from supporters and naysayers alike. About the eccentricity of novelty typeface designers, one critic exhorted: "These desperate fellows did indeed invent an elaborate technique whereby an A was decapitated so as to make it look as much like a battered H as possible; an H had its legs tilted towards each other in order to make it as like an A as possible; S's looked like J's, and J's looked like nothing at all." In an article titled "What Are the Fruits of the New Typography" (*Penrose Annual*, 1935), advertising manager John C. Tarr concurred that while this manifestation reflected the spirit of modern times, "for a few years [it] was rather the worse for typography, and every kind of eccentricity, both in illustration, type face, and type arrangement was to be observed." Another critic wrote harshly about quirky design: "I have no hesitation in saying that, apart from novelty, they were, in the main, failures." And yet another went so far as to insist that "If those who are not masters in modernism will only have the courage to realize their deficiencies and to stop trying to do things beyond their powers and outside their imagination, their advertisements will charm, while those … who continue on the imitative course will be merely unpleasing."

Undermining the gems of modernism, there were indeed shocking—what one critic called *sturm und drang*—advertisements that used modernistic tropes as a sledge hammer. While the best were well crafted and smartly conceived, it was inevitable that sloppy imitations would emerge. For a more or

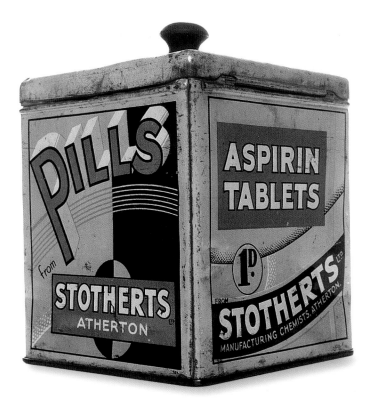

less accurate picture of English Modern design between the world wars the examples shown in this book include the masterpieces of functional simplicity that characterized the best of the modern as well as the excessive concoctions that evolved or devolved.

The modern wave ebbed in the late 1930s as England adopted a more refined and austere modernism, consistent with the work of the defunct Bauhaus (closed by the Nazis in 1933). By 1940, the war and its resulting privations put an end to the Art Deco period. Advertising budgets were slashed and many of Britain's commercial artists turned their attention to home-front and war-related propaganda. The vestiges of the stylish visual vocabulary continued to appear into the early 1940s, but English Modern was definitely a victim of the blitz.

The Vorticist group of painters, led by Wyndham Lewis, is often thought of as Britain's only original fine art movement of the twentieth century. As unique as it was in England, it was decidedly influenced by, if not a pale imitation of, French Cubism and Italian Futurism. But it was nevertheless the touchstone for a few of Britain's modern poster artists of the early 1920s. The most renowned of these was responsible for a large number of the cultural posters (as well as other genres) preserved today. E. McKnight Kauffer, an American expatriot who came to England as a painter and became a leading commercial artist, contributed to and created public taste instead of merely following it. "There is nothing popular in the ordinary sense about Kauffer's work," wrote John Harrison in *Posters and Publicity: Fine Printing and Design* (1927). "It is abstract and advanced. Yet public interest has been roused to a great degree. Mr. Kauffer rivals the best of the Continental commercial designers. He is not, however, specifically English in quality." Kauffer's work was a synthesis of European modern artistic inventions—collage, montage, flat color fields, layered transparencies, and more. But his work, which was ubiquitous in England between 1919 and 1939, was a measure of the British visual culture of the era. Of course he was not alone in creating publicity for cultural events, but in this chapter it is clear that his contributions creatively far outdistanced the other artists who relied on spruced up traditional narratives. Kauffer's typography and imagery were modern to a fault. In the cultural arena—particularly with publicity for arts and architecture events—Kauffer's cubistic method was well suited and received. But not all cultural happenings were as avant-garde as these. So an equal number of the works in this chapter represent a populist culture, cabaret, or music hall experience.

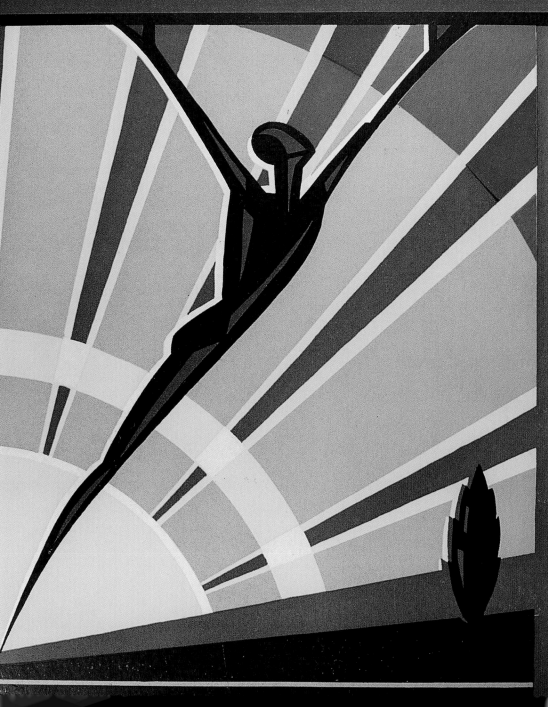

THE WAY OF THE SUN

ARTS AND
CRAFTS
MAGAZINE
COVER, 1929
ARTIST:
E. MCKNIGHT
KAUFFER

ARTS AND CRAFTS

VOLUME III
NUMBER TWO
NEW SERIES
JULY 1929

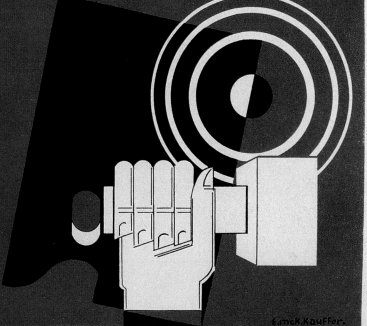

E.mcK.Kauffer.

CONTENTS

THE ULTIMATE SOUND
FILMS: CONTEMP-
ORARY INTERIOR DE-
CORATION: STATUES,
MR. EPSTEIN, AND THE
PUBLIC: PRESENT DAY
DESIGN IN FRANCE:
THE ARTS AND CRAFTS
OF CANADA: THE
SECRET OF MODERN
ARCHITECTURE: CRIT-
ICISM AND APPLIED
ART: MODERN OFFICE
FURNITURE: JOURNAL-
ISM AND ART: MALAY
ARTS AND CRAFTS:
OLD IRISH GLASS:
DIVERTIMENTI: ETC.

A REVIEW OF
MODERN TASTE

PRICE
ONE
SHILLING

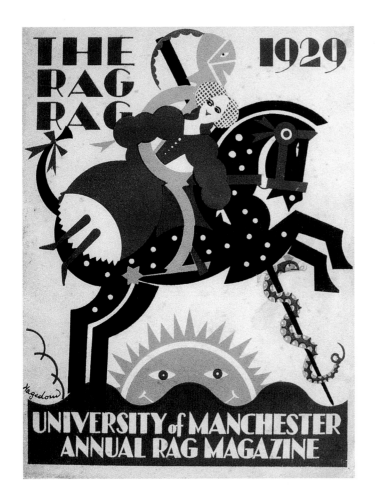

THE RAG RAG

MAGAZINE COVER, 1929

ARTIST: HAGENDORN

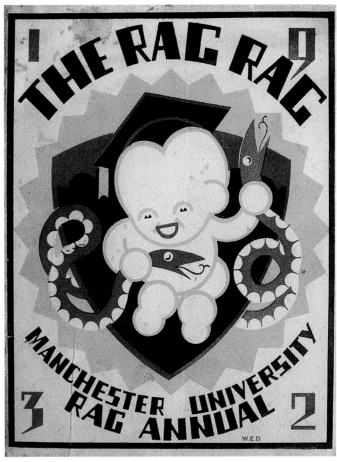

THE RAG RAG

MAGAZINE COVER, 1932

ARTIST: W. E. D.

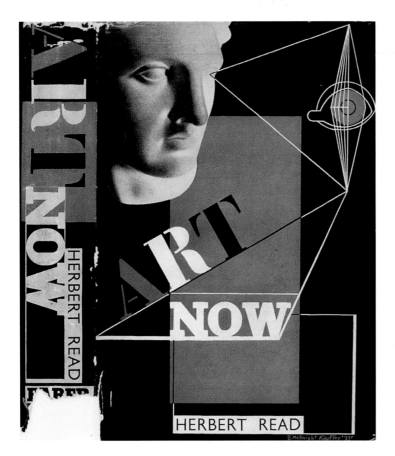

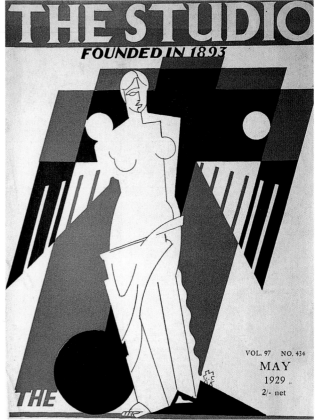

ART NOW

BOOK JACKET, 1933

ARTIST: E. MCKNIGHT KAUFFER

THE STUDIO

MAGAZINE COVER, 1929

ARTIST: E. MCKNIGHT KAUFFER

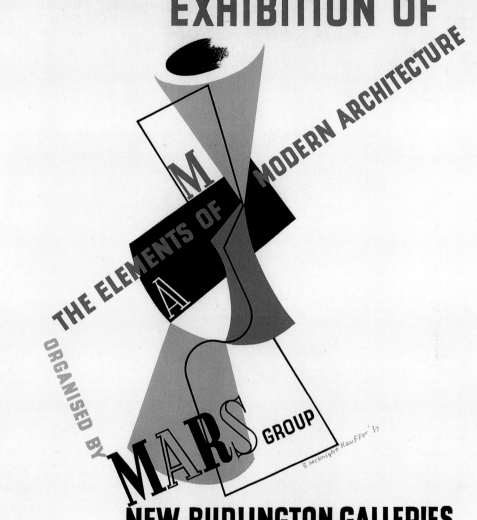

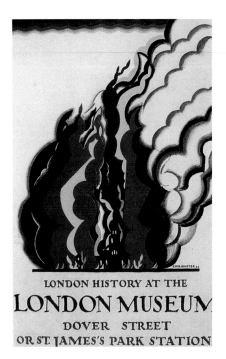

LONDON HISTORY AT THE
LONDON MUSEUM
DOVER STREET
OR ST. JAMES'S PARK STATION

LONDON MUSEUM

POSTER, 1922

ARTIST: E. MCKNIGHT KAUFFER

THE RED DANCER
OF MOSCOW

BOOK JACKET, C. 1930

ARTIST UNKNOWN

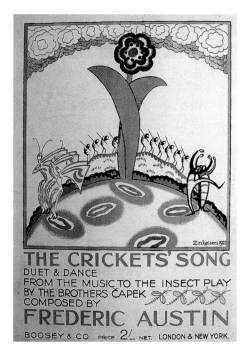

THE CRICKETS' SONG
DUET & DANCE
FROM THE MUSIC TO THE INSECT PLAY
BY THE BROTHERS ČAPEK
COMPOSED BY
FREDERIC AUSTIN
BOOSEY & CO. PRICE 2/ NET. LONDON & NEW YORK.

THE CRICKETS' SONG

POSTER, 1923

ARTIST: ZINKEISEN

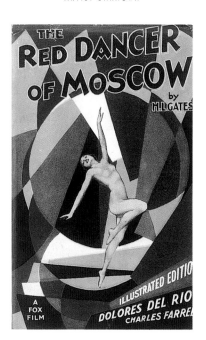

THE
RED DANCER
OF MOSCOW
by
H.L.GATES

ILLUSTRATED EDITION
A FOX FILM
DOLORES DEL RIO
CHARLES FARRELL

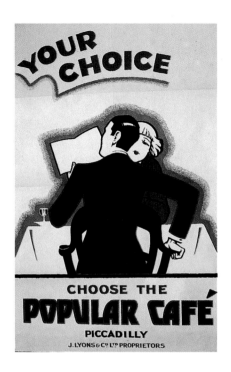

POPULAR CAFÉ

POSTER, C. 1927

ARTIST: RAE

"PUPPETS!"

POSTER, C. 1928

ARTIST: AUBREY HAMMOND

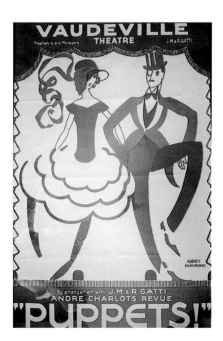

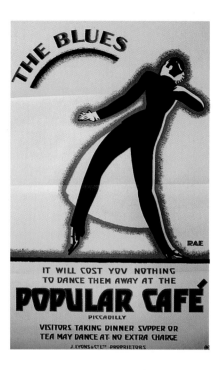

POPULAR CAFÉ

POSTER, C. 1927

ARTIST: RAE

COMMUNICATION

If modernism equals progress and progress equals communication, then modernism equals communication. Therefore, it is no surprise that modern design had an early foothold in the publicity for the English communications industry, specifically radio, telegraph, and newspapers. Perhaps the first sign of modernism was a 1919 poster by E. McKnight Kauffer for the *Daily Herald* entitled "Soaring To Success! The Early Bird," based on an earlier print titled "Flight" (1916), which was also the first cubistic advertising poster in England. This otherwise innocuous picture of birds on the wing was raised to a modernist icon by the stark, schematic rendering of the birds against a flat yellow background, which was indeed unusual for its time. From that moment it was common to see avant-gardisms that symbolized machine age progress in posters and ads. The BBC (British Broadcasting Company) was an early proponent of modernism, hiring Kauffer, among others, to contribute artwork to its growing number of program guides. But it was *Radio Times* magazine that produced the most consistently modern artworks, mostly for its covers. Here modernism was a house style influenced both by the avant-garde arts (Cubism, Vorticism, Constructivism) and the leading progressive commercial artists, including France's A. M. Cassandre (see page 28). These covers used reductive forms and essential geometries, as well as decorative and representational imagery. The airbrush had been christened the machine age artist's tool, and so a fair number of designs promoting communication were rendered with streamlined tonality and kinetic linearity. In the wake of modernism there was a lot of pseudo-modern design produced by, as one critic described it, "the smart-aleck who can always turn on a bit of modern stuff, if you want it." But that was inevitable.

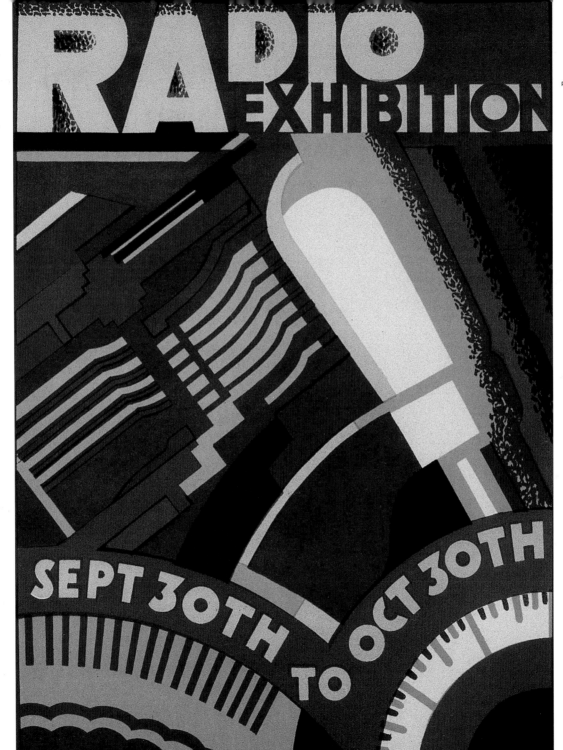

RADIO
EXHIBITION

**RADIO
EXHIBITION**
POSTER, C. 1930
ARTIST
UNKNOWN

SEPT 30TH TO OCT 30TH

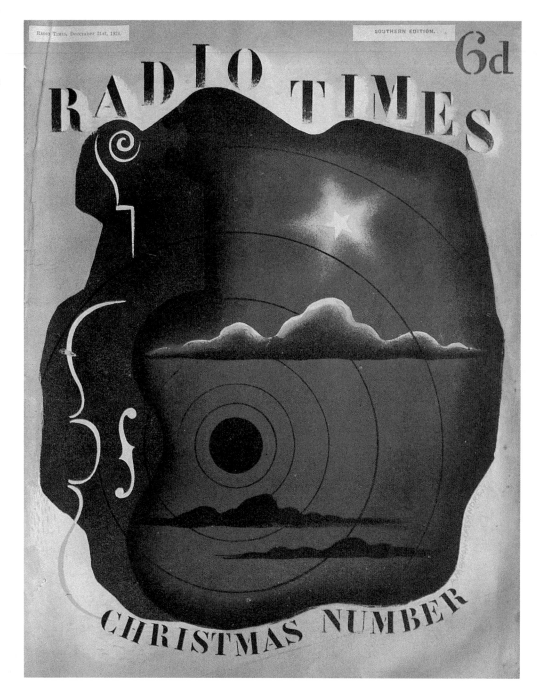

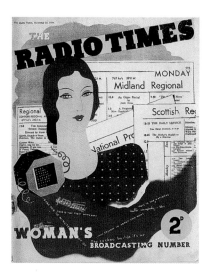

RADIO TIMES

MAGAZINE COVER, 1934

ARTIST UNKNOWN

RADIO TIMES

MAGAZINE COVER, 1927

ARTIST UNKNOWN

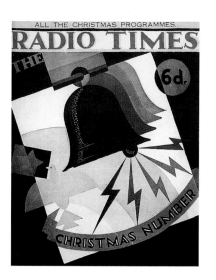

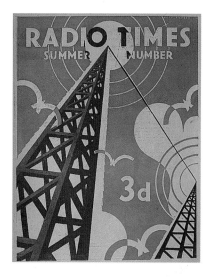

RADIO TIMES

MAGAZINE COVER, 1930

ARTIST: ERIC FRASER

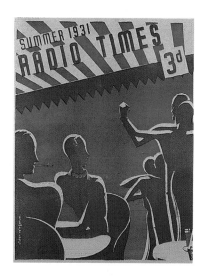

RADIO TIMES

MAGAZINE COVER, 1931

ARTIST: VICTOR REINGANUM

RADIO TIMES

MAGAZINE COVER, 1929

ARTIST: SHEP

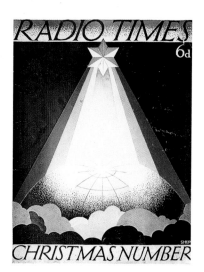

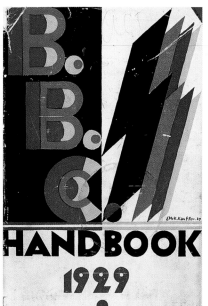

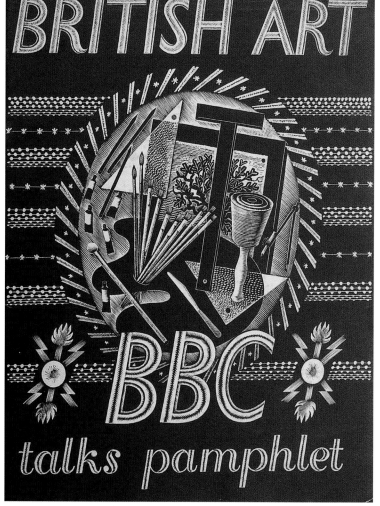

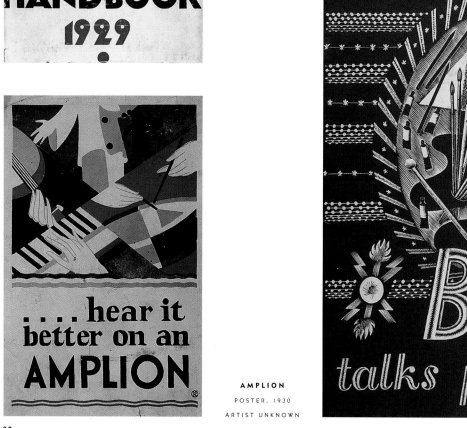

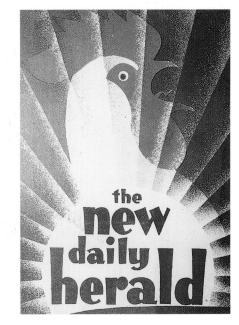

RALD

LOR

THE DAILY HERALD

POSTER, C.1928

ARTIST: GRIMMOND

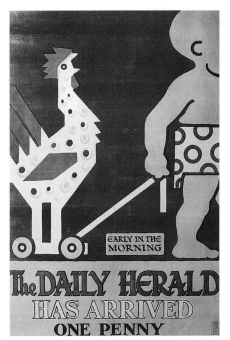

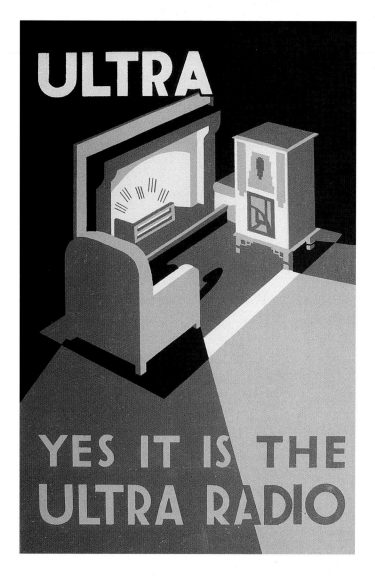

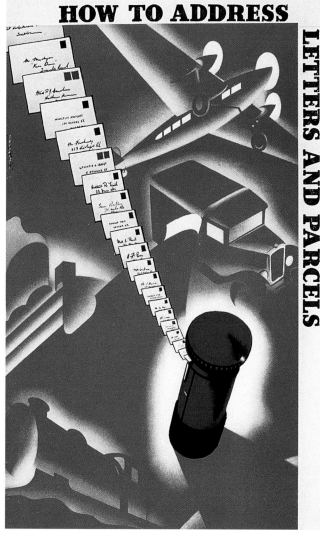

ULTRA

BROCHURE, C. 1928

ARTIST UNKNOWN

HOW TO ADDRESS

BROCHURE, C. 1928

ARTIST UNKNOWN

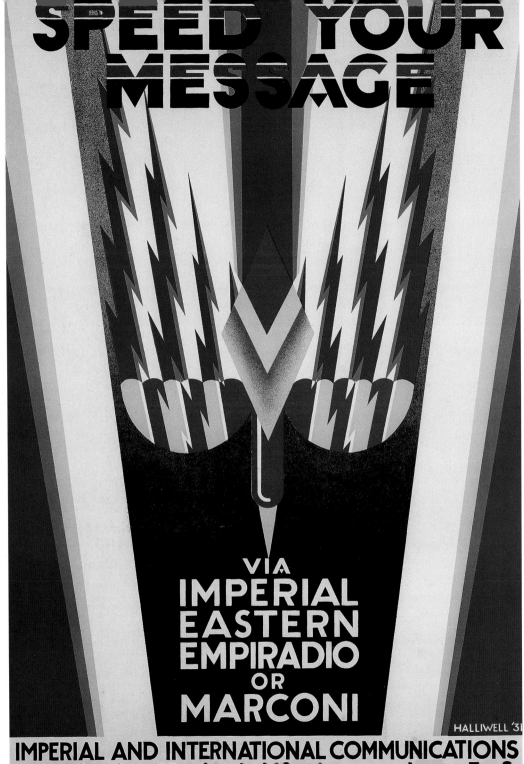

FASHION

The promotion of fashion was well served by the Art Deco style. Haute couture and daily dress were mythologized through simplified representations of the human form set against modernistic backdrops. In England this publicity was influenced by modern French and German mannerisms—the former, cubistic renderings of men and women; the latter, reductive, essential outlines and color fields. Tom Purvis masterfully adapted the German "sachplakat" (object poster) method in his images for Austin Reed's, England's quality men's clothier. Purvis's male figures were monumental yet also identified with the average consumer. Most women, on the other hand, were rendered inertly as if they were robots, prompting Lucy B. Kitchin to write in *Advertising Display* (January, 1929) a critique entitled "Why Not A Natural Woman?" She was referring to the proliferation of "the Puppet Lady." This mannerism, which is the emblem of the moderne female, was started by the fashion artists who, as Kitchin argued, "did not want to spend too long over the portrayal of the woman wearing the dress that had to be shown, but because no two editors had the same ideal of a beautiful woman, they all disagreed heartily and heatedly …" The vogue swung from the ultra-realistic drawing to stylized design void of individual characteristics. "The evolution of this woman," continued Kitchin, "could be shown as the 'Smart Woman' in so many countries …. But in losing nationality she lost also her individuality, and for this reason she is in danger of losing her being." Apparently there was another reason for this trend. "So little artistic ability is required on the part of those who perpetrate these things," wrote one store's advertising manager in *Advertising Display*, "that they naturally do not cost nearly as much as good artistic drawings do. This alone is sufficient recommendation to endow them with eternal life…."

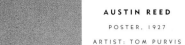

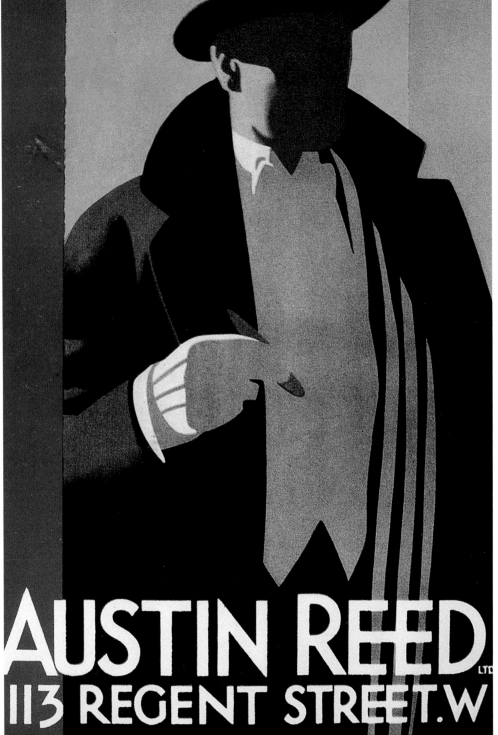

RIGHT:

AUSTIN REED'S

POSTER, 1927

ARTIST: TOM PURVIS

BELOW:

AUSTIN REED'S

POSTER, 1928

ARTIST: AUSTIN COOPER

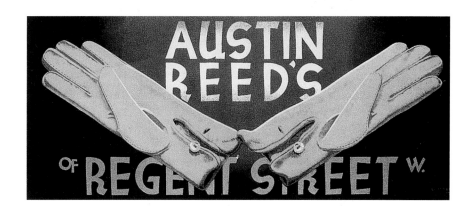

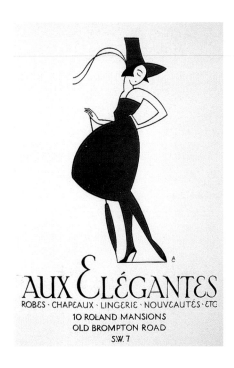

AUX ÉLÉGANTES

ADVERTISEMENT, 1923

ARTIST: ALDO COSOMATIC

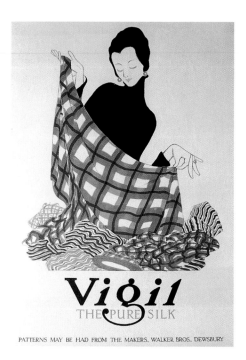

VIGIL

POSTER, 1925

ARTIST UNKNOWN

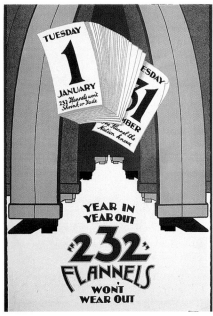

FLANNELS

POSTER, C. 1928

ARTIST UNKNOWN

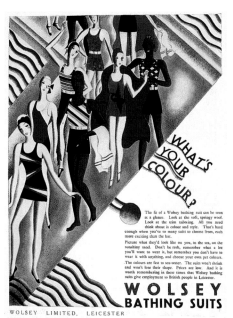

WOLSEY

ADVERTISEMENT, 1930

ARTIST UNKNOWN

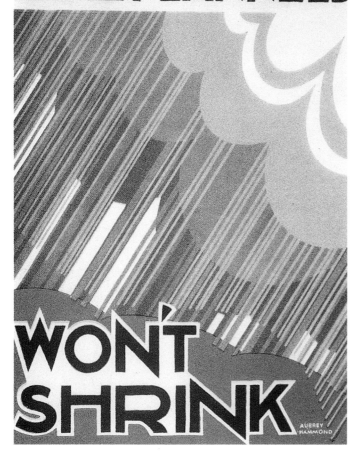

WON'T SHRINK

POSTER, C. 1927

ARTIST: AUBREY HAMMOND

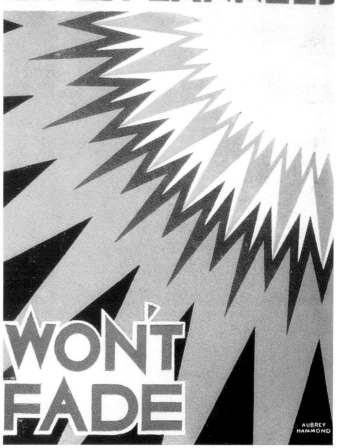

WON'T FADE

POSTER, C. 1927

. ARTIST: AUBREY HAMMOND

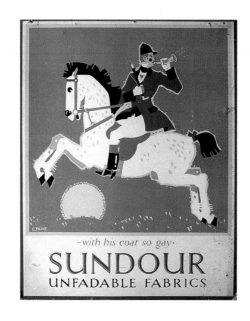

SUNDOUR

SHOWCARD, C. 1928

ARTIST: C. PAINE

DERRY & TOMS

POSTER, C. 1919

ARTIST: E. MCKNIGHT KAUFFER

BOBBY & CO., LTD.

POSTER, C. 1928

ARTIST: GREGORY BROWN

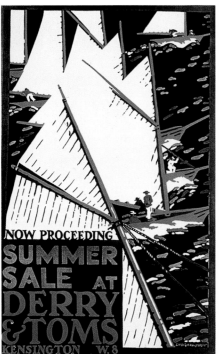

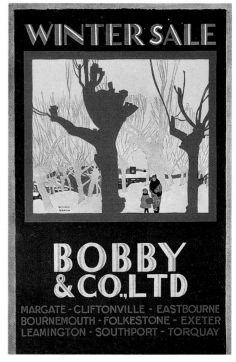

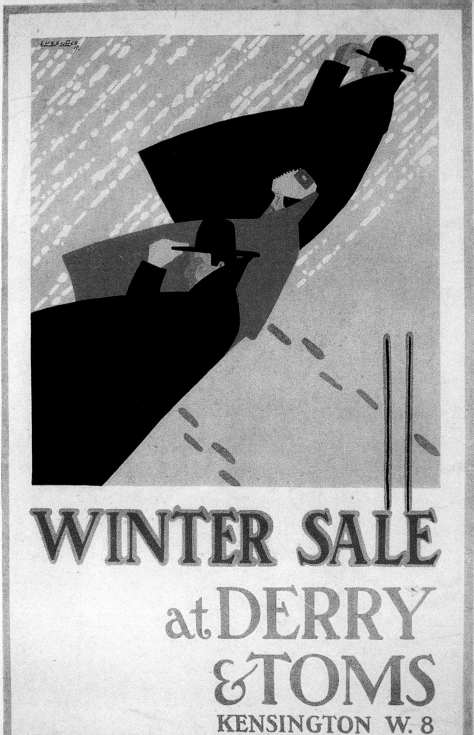

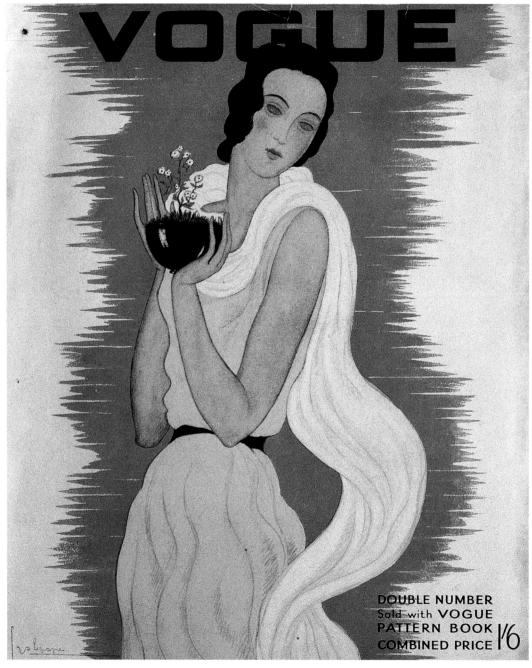

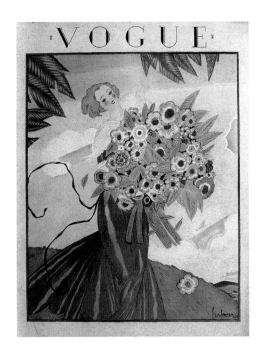

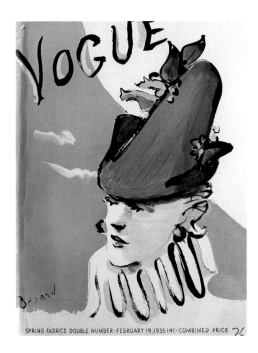

VOGUE

MAGAZINE COVER, 1923

ARTIST: GEORGE LAPAPE

VOGUE

MAGAZINE COVER, 1936

ARTIST: BERARD

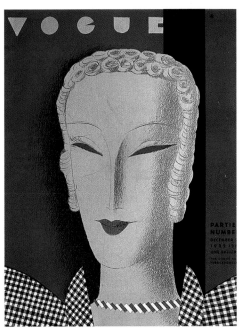

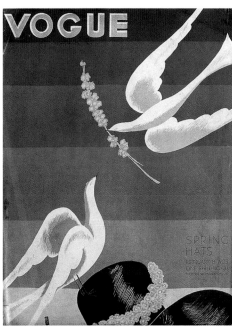

VOGUE

MAGAZINE COVER, 1932

ARTIST: BENITO

VOGUE

MAGAZINE COVER, 1936

ARTIST: BENITO

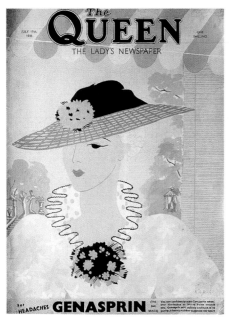

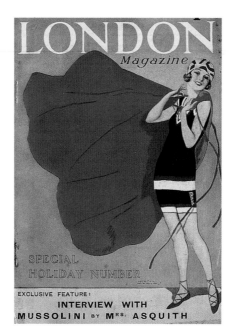

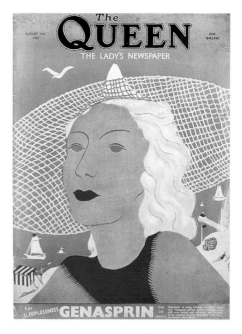

THE QUEEN

MAGAZINE COVER, 1935

ARTIST: KARAS

LONDON

MAGAZINE COVER, C. 1932

ARTIST: WILTON WILLIAMS

THE QUEEN

MAGAZINE COVER, 1935

ARTIST: KARAS

UNTITLED

SHIRT BOX, C. 1930

ARTIST UNKNOWN

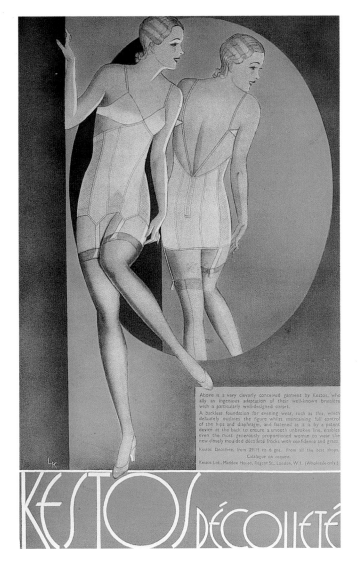

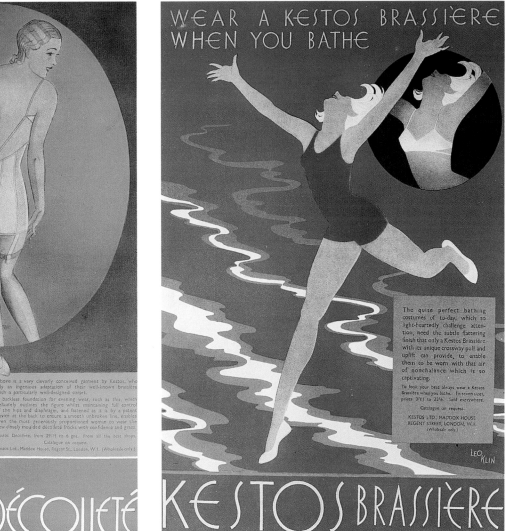

KESTOS

ADVERTISEMENT, 1932

ARTIST: LEO KLIN

KESTOS

ADVERTISEMENT, 1932

ARTIST: LEO KLIN

HOMEFRONT

England won the Great War and preserved its empire (temporarily), but the peace did not last for long. Despite persistent calls for disarmament (such as the poster designed by Austin Cooper on the opposite page), Europe was poised for another conflagration and artists were conscripted as early propagandists. There were various homefront drives resulting in poster campaigns and other graphics barrages. Before the Blitz wreaked havoc on English cities, attention was focused on issues of industrial production and safety. Posters cautioned against fire, personal injury, and poor health while promoting increased efficiency in the workplace. "Buy British" was a constant theme throughout the empire. As increased post-war competition from other European nations and the United States threatened the United Kingdom's trade balance, artists were commissioned to promote the vast market resources of the empire. Once the fighting began in 1940, to support the war effort annual publicity campaigns urged citizens to buy war bonds and to otherwise morally support the troops through letters and packages. To protect the citizenry against Germany's unrelenting bombardments, Air Raid Precautions were enforced by municipal civil defense councils. Public involvement in these councils was promoted through striking poster art. Throughout the war years posters served both to caution against wasted resources and loose lips, and to encourage communal aid and war production. Although Art Deco had ceased to be the dominant graphic style, austere modernism still prevailed. Posters by a few of the older generation, including Tom Purvis, and the younger generation of English modernists, Thomas Eckersley and Abram Games, used reductive and surrealist design idioms in their work. Decoration was rejected in favor of visually provocative symbolism that shouted messages as loudly and clearly as an air raid siren.

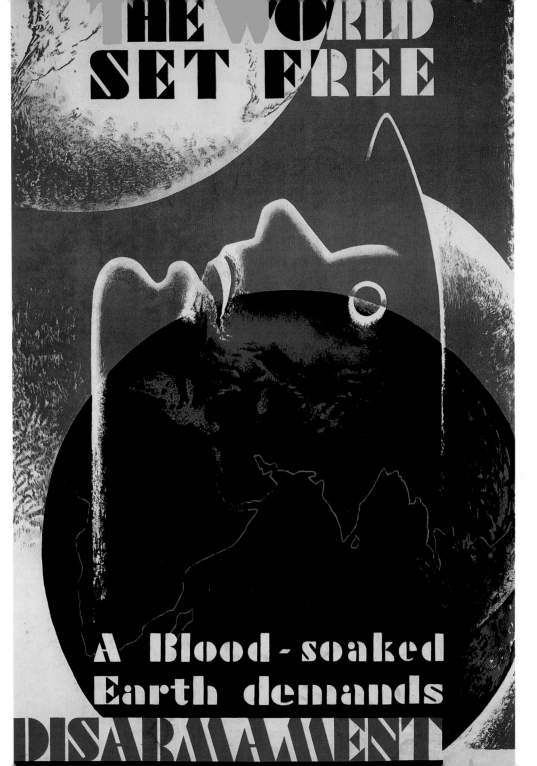

THE WORLD SET FREE

A Blood-soaked Earth demands

DISARMAMENT

THE WORLD
SET FREE
POSTER, 1925
ARTIST:
AUSTIN COOPER

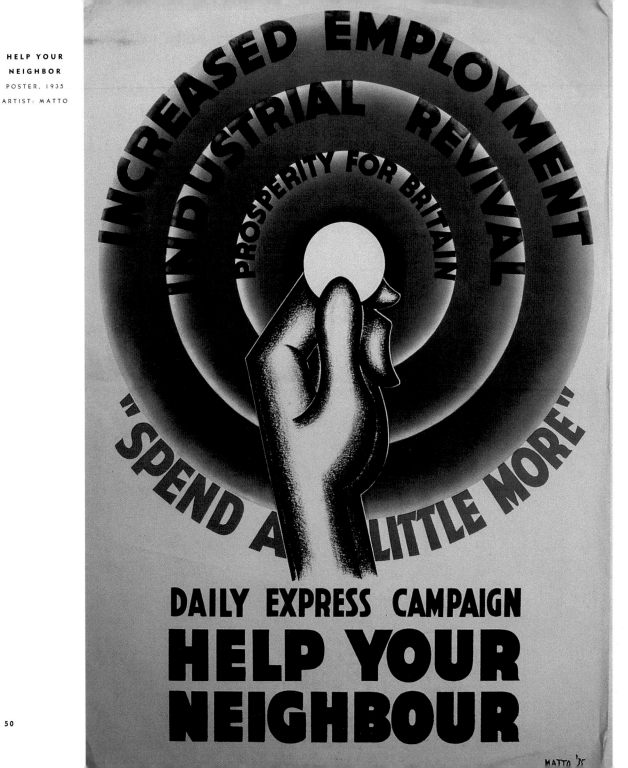

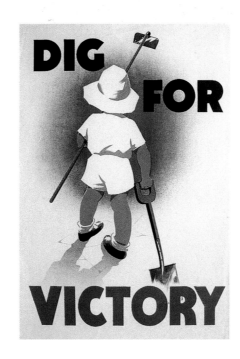

DIG FOR VICTORY

POSTER, C. 1943

ARTIST: MARY TURNBRIDGE

THE ROAD TO VICTORY

POSTER, C. 1942

ARTIST UNKNOWN

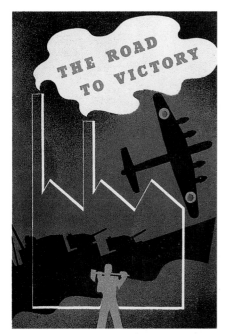

WAR WEAPONS DRIVE

POSTER, 1944

ARTIST UNKNOWN

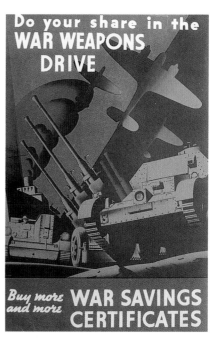

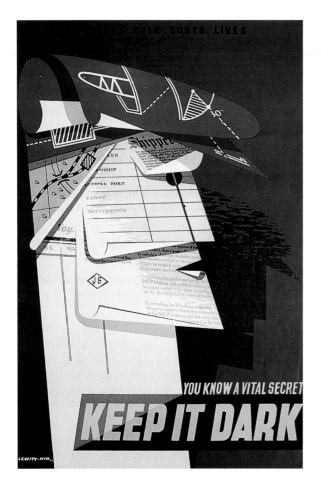

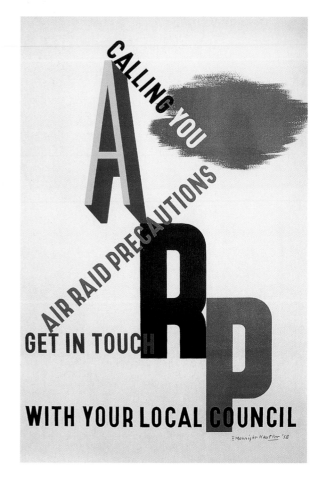

KEEP IT DARK

POSTER, 1944

DESIGNER: LEWITT-HIM

ARP

POSTER, 1938

DESIGNER: E. McKNIGHT

KAUFFER

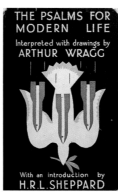

**THE PSALMS
FOR MODERN LIFE**

BOOK JACKET, C. 1938

ARTIST: WOLF

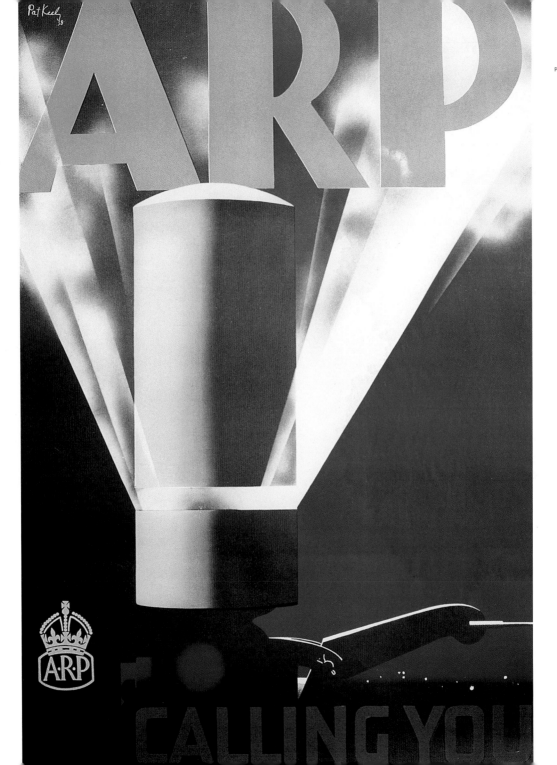

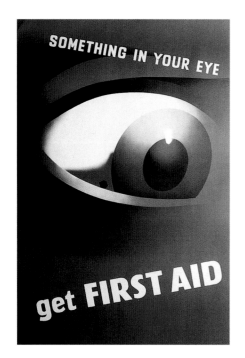

GET FIRST AID

POSTER, 1939

ARTIST: COUCLEN

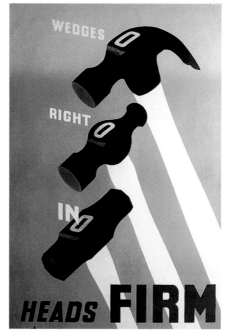

HEADS FIRM

POSTER, C. 1939

ARTIST: COUCLEN

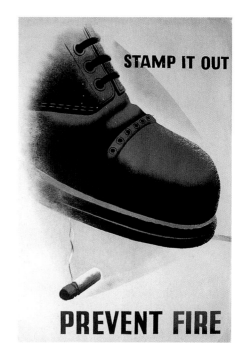

PREVENT FIRE

POSTER, C. 1940

ARTIST: TOM ECKERSLEY

BONES

POSTER, C. 1942

ARTIST UNKNOWN

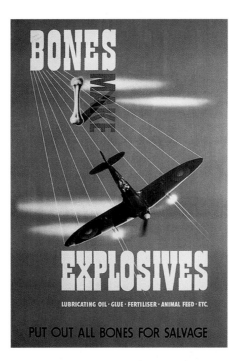

WAIT

POSTER, C. 1943

ARTIST: G. R. MORRIS

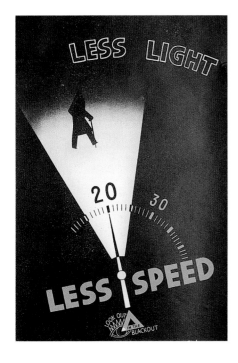

LESS LIGHT

POSTER, 1940

ARTIST: PAT KEELY

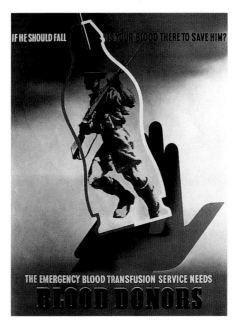

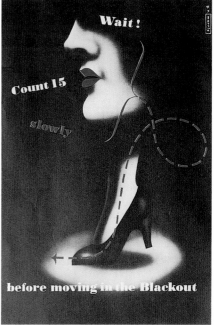

BLOOD DONORS

POSTER, 1943

ARTIST: ABRAM GAMES

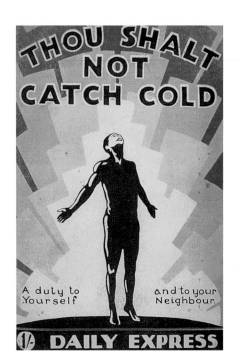

THOU SHALT
NOT CATCH COLD
BROCHURE COVER, 1925
ARTIST UNKNOWN

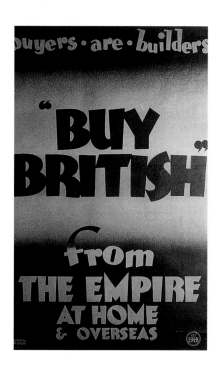

BUY BRITISH
POSTER, C.1937
ARTIST: AUSTIN COOPER

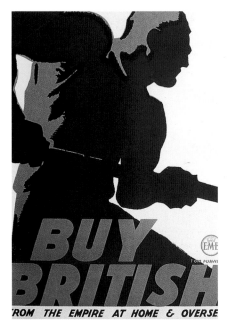

BUY BRITISH
POSTER, C.1937
ARTIST: TOM PURVIS

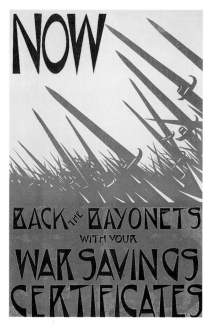

WAR SAVINGS
CERTIFICATES
POSTER, C.1917
ARTIST UNKNOWN

SAFEGUARD
YOUR FRIENDSHIP
SEND
CHRISTMAS
CARDS

SAFEGUARD
YOUR FRIENDSHIP
POSTER, C. 1940
ARTIST UNKNOWN

UNDERGROUND

Modern English graphic design began underground and surged upward. Posters for the London Underground, which advertised its services as well as scenic sights occurring within range of its lines and stations, evolved under the direction of Frank Pick from prosaic landscapes to stylized abstractions. Pick had a vision of a better urban environment and was determined to use his position as director of publicity to educate and raise the public's standard of taste. The posters avoided the overtly hard-sell images common to most advertising in favor of subtle allusions to the advertised themes. For the most part this modern approach was popular among passengers and artists alike. "The Underground Railway is ... a tower of strength to the case of artistic advertising," wrote John Harrison in *Posters and Publicity: Fine Printing and Design* (1927). But some critics nevertheless argued against the viability of modern art: "By all means try and educate the public taste," wrote G.W. Duncan in *Penrose Annual* (1935), "but do not use commercial posters simply as an indirect form of publicity for artists and art galleries." Yet critiques of the Underground's modernism paled next to the actual results. The posters strikingly illustrated London's beauty spots and maintained an unceasing flow of unique and amusing designs by the most capable artists of the day. The Underground was, moreover, a pioneer of integrated design strategies. In addition to posters, Pick commissioned Edward Johnston to design a block-letter alphabet exclusively used for station signs and notices that exerted an immense influence on all modern English type design. Pick also asked Johnston to design the Underground's bullseye (or red-ring) logo. It was inspired by the YMCA triangle—"only more balanced," according to Pick. The mark, found on all the Underground posters, is still used today.

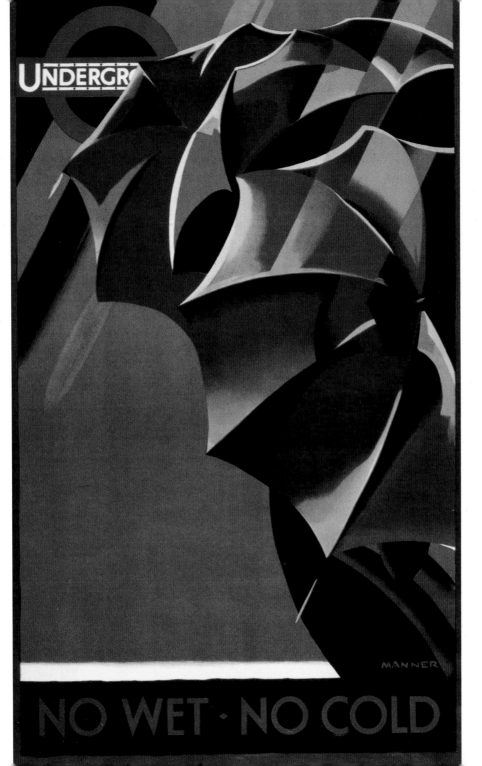

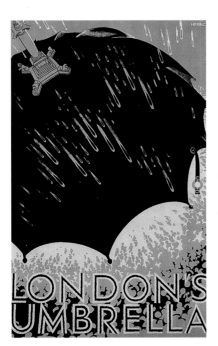

THANKS TO
THE UNDERGROUND
POSTER, 1935
ARTIST: ZERO
(HANS SCHLEGER)

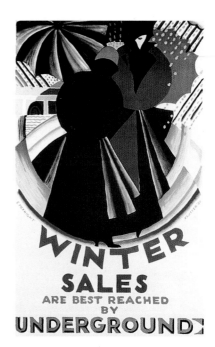

WINTER SALES
POSTER, 1924
ARTIST: E. MCKNIGHT
KAUFFER

LONDON'S UMBRELLA
POSTER, 1925
ARTIST: F.C. HERRICK

KEEP PACE WITH TIME
POSTER, 1927
ARTIST: F.C. HERRICK

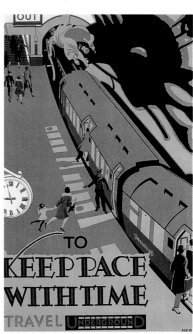

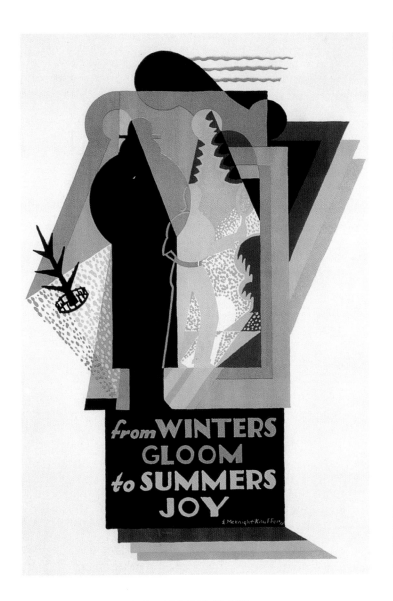

FROM WINTERS GLOOM...

POSTER, 1927

ARTIST: E. McKNIGHT KAUFFER

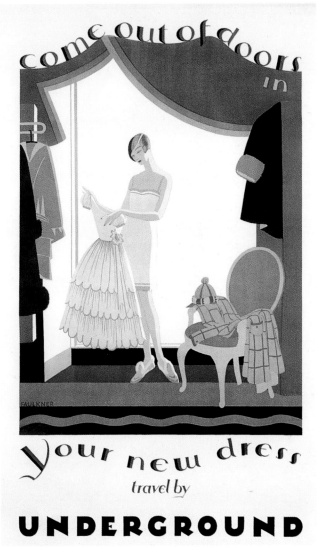

COME OUT OF DOORS

POSTER, 1928

ARTIST: ALMA FAULKNER

SEASON TICKETS

SAVE TIME

SAVE TIME

SAVE TIME

DON'T STAND IN A QUEUE

BE ON YOUR WAY WITH A SEASON

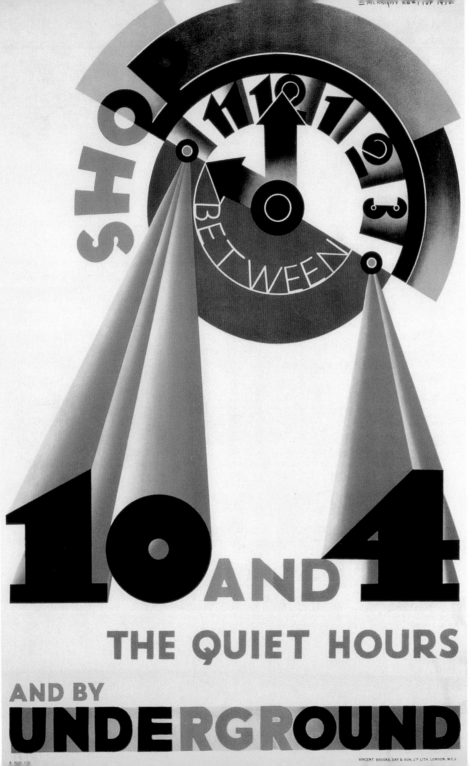

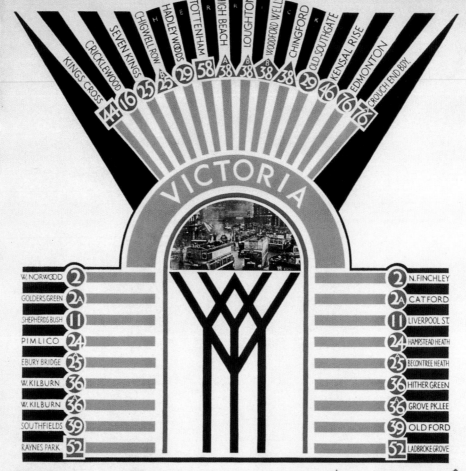

A MAIN LINE
STATION

WHAT A SYSTEM OF
BUS ROUTES MEANS?
720 BUSES ARE WANTED
TO WORK THIS NETWORK
OF 21 SERVICES

MAY 1923

**A TRAIN EVERY
90 SECONDS**

POSTER, C. 1937

ARTIST: ABRAM GAMES

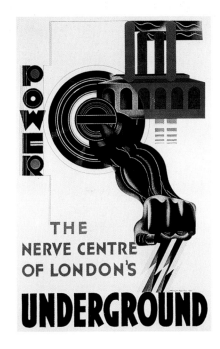

**THE
NERVE CENTRE
OF LONDON'S
UNDERGROUND**

SPEED

POSTER, 1930

ARTIST: ALAN ROGERS

POWER

POSTER, 1931

ARTIST: E. MCKNIGHT

KAUFFER

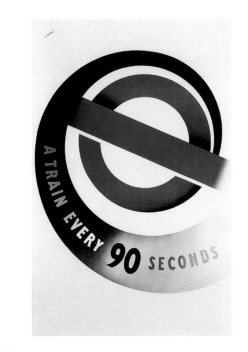

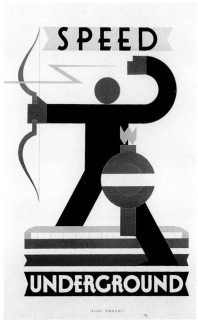

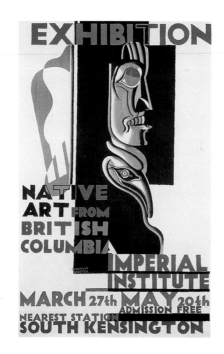

EXHIBITION

POSTER, C. 1925

ARTIST: E. MCKNIGHT

KAUFFER

CERAMICS

POSTER, C. 1930

ARTIST: AUSTIN COOPER

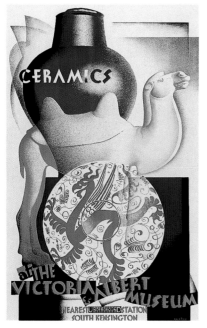

AMERICA

POSTER, C. 1930

ARTIST: AUSTIN COOPER

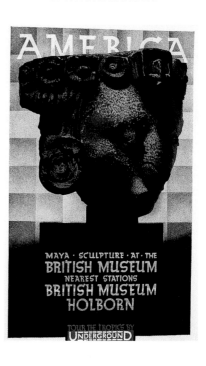

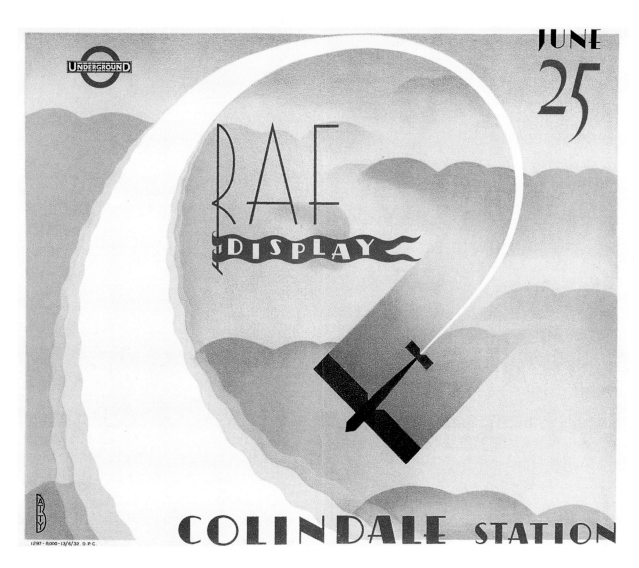

RAF DISPLAY

POSTER, 1932

ARTIST: DORA BATTY

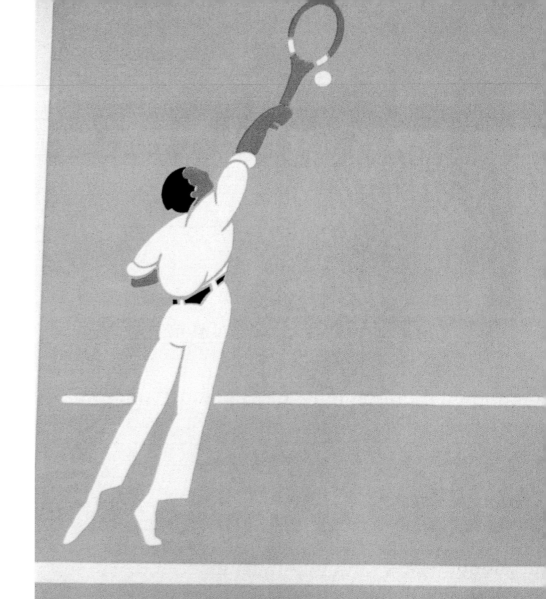

FOR THE WIMBLEDO

NEAREST STATION

SOUTHFIELDS

OURNAMENT JUNE 25th

PECIAL BUSES TO & FROM

HE STATION AND GROUND

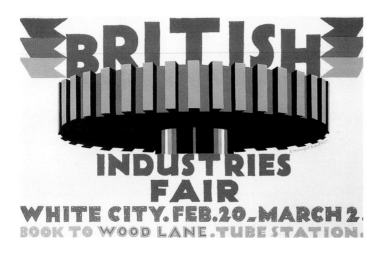

BRITISH
INDUSTRIES FAIR
POSTER, 1928
ARTIST: E. MCKNIGHT KAUFFER

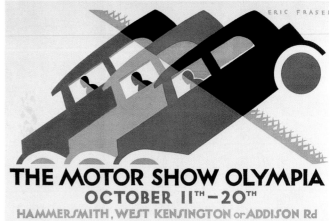

THE MOTOR
SHOW OLYMPIA
POSTER, 1928
ARTIST: ERIC FRASER

MOTOR SHOW
POSTER, 1928
ARTIST: HERRY PERRY

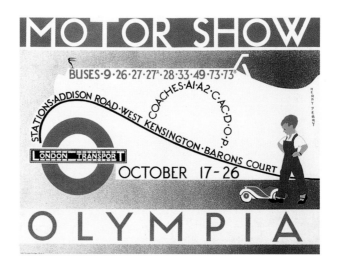

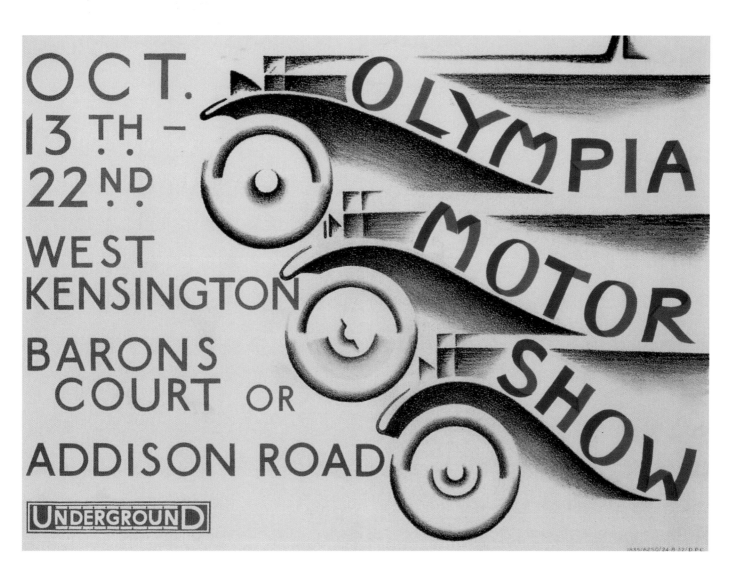

OLYMPIA MOTOR SHOW

POSTER, 1932

ARTIST UNKNOWN

INDUSTRY

Unlike France, Germany, and Russia, to name a few industrialized nations that embraced artists, English industry was not always a willing recipient of art in the service of commerce. While industrial leaders more or less understood the value of advertising to promote their wares to the masses, they saw it as being rather straightforward and not to be mucked about by modern design. Some industrial leaders and advertising critics looked upon the conceits of modern designers as distracting from the job at hand—to sell the goods. "In the majority of British industries today," wrote W. D. H. McCullough in *Commercial Art and Industry* (1931), "the accountant and the engineer have far too much say, and the artist has far too little." Industry paid lip service to artists whom McCullough describes as having been "snatched from Chelsea and dumped into enormous factories in the North Country, where they have been set down in dank and gloomy offices and told to be artistic." Change began to take place when it was pointed out that once again the Germans were taking the lead in the areas of both industrial and advertising design. British industry gradually came around to accepting modernism as a code for progress. The creation of Art Departments for Industry in the early 1930s had a lot to do with a fundamental change in attitude, as did the artistic and creative advisors who insinuated themselves in corporate decisions. On the government side, by 1932 in London both the Board of Trade and the Board of Education established a departmental committee to deal with art and industry (later to be known as the British Arts Council). The goal of the committee was to develop in London a standing exhibition of good design and current manufacture and to organize local and traveling exhibitions. In turn these exhibits (including fairs devoted to advertising) influenced the nature of industrial design throughout the 1930s.

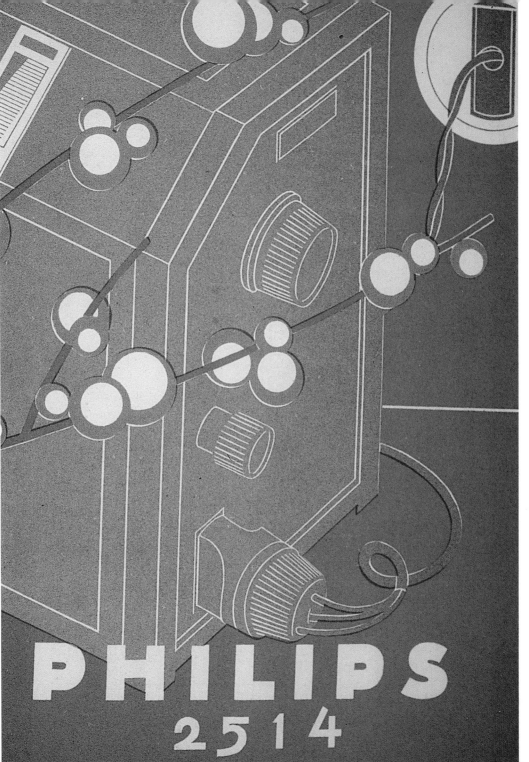

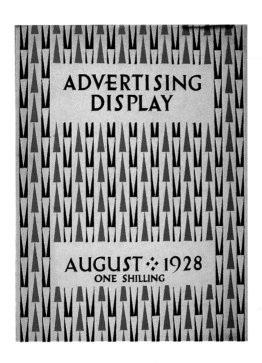

ADVERTISING DISPLAY

MAGAZINE COVER, 1928

ARTIST UNKNOWN

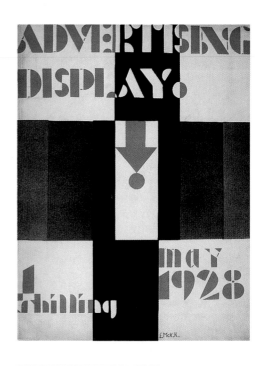

ADVERTISING DISPLAY

MAGAZINE COVER, 1928

ARTIST: E. MCKNIGHT KAUFFER

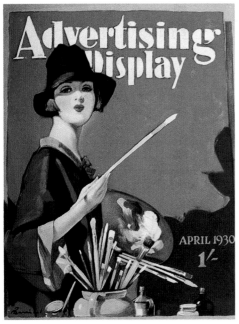

ADVERTISING DISPLAY

MAGAZINE COVER, 1930

ARTIST: BARRIBAL

ADVERTISING DISPLAY

MAGAZINE COVER, 1929

ARTIST UNKNOWN

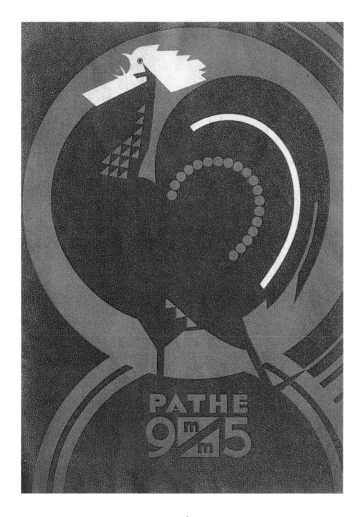

PATHÉ 95

POSTER, 1928

ARTIST UNKNOWN

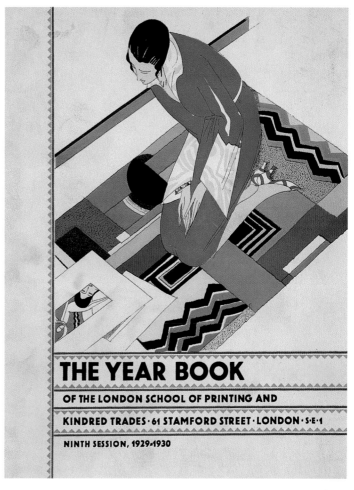

THE YEAR BOOK

BOOK COVER, 1929

ARTISTS: WALLACE & TIERNAN

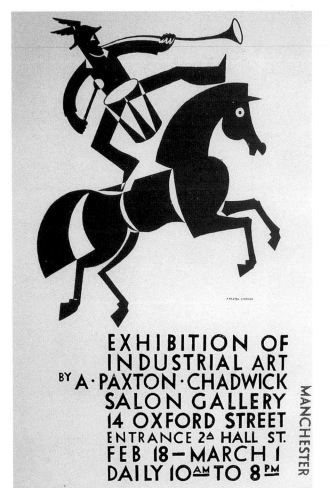

**EXHIBITION OF
INDUSTRIAL ART**

POSTER, C. 1928

ARTIST: A. PAXTON

CHADWICK

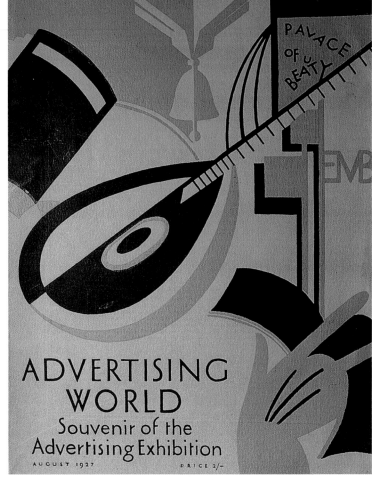

ADVERISING WORLD

MAGAZINE COVER, 1927

ARTIST: F. HINDLE

NOBEL

POSTER, 1924
ARTIST UNKNOWN

THE SUN

ADVERTISEMENT, 1921

ARTIST: E. MCKNIGHT

KAUFFER

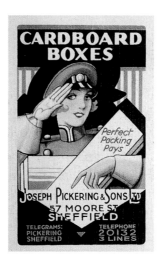

CARDBOARD BOXES

ADVERTISEMENT, C. 1925

ARTIST UNKNOWN

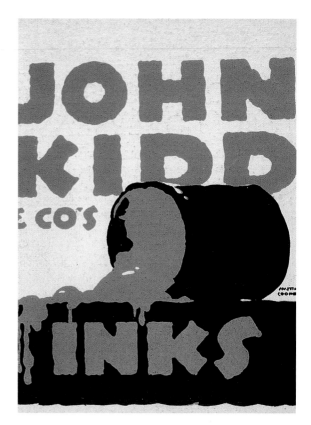

JOHN KIDD

ADVERTISEMENT, 1924

ARTIST UNKNOWN

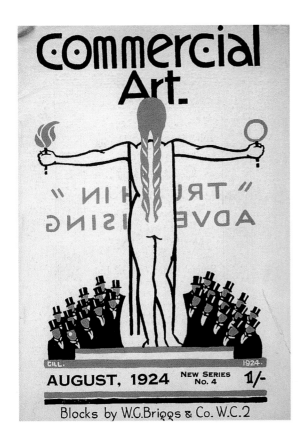

COMMERCIAL ART

MAGAZINE COVER, 1924

ARITST: GILL

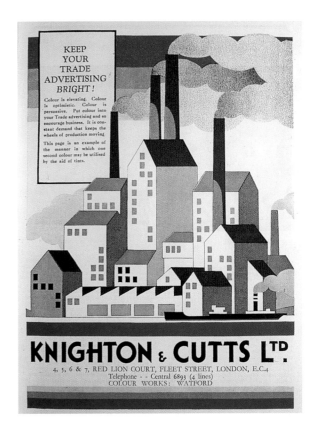

KNIGHTON & CUTTS LTD.

ADVERTISEMENT, 1926

ARTIST UNKNOWN

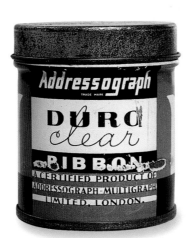

DURA CLEAR

TIN, C. 1930

ARTIST UNKNOWN

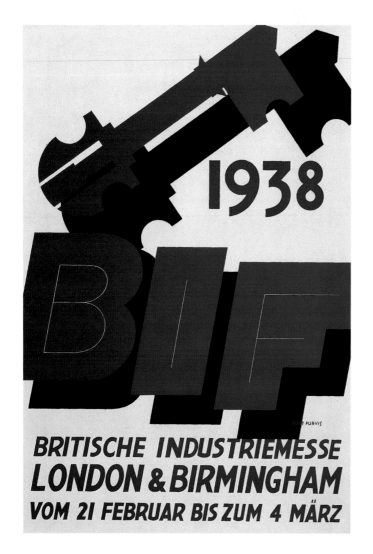

BRITISCHE
INDUSTRIEMESSE
POSTER, 1938
ARTIST: TOM PURVIS

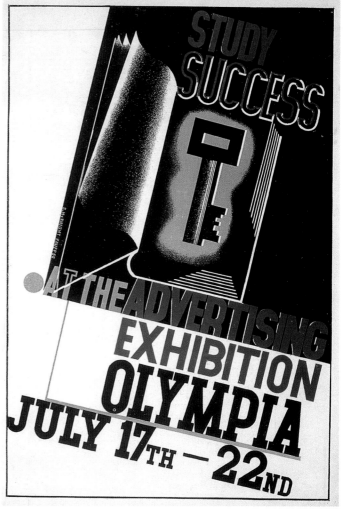

EXHIBITION OLYMPIA
CATALOG COVER, 1927
ARTIST: E. MCKNIGHT
KAUFFER

BIA
POSTER, C. 1928
ARTIST:
AUSTIN COOPER

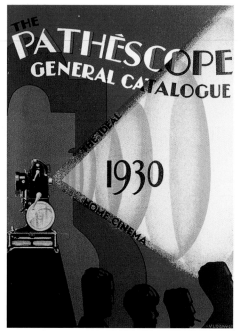

PATHÉSCOPE

CATALOG COVER, 1930

ARTIST: V. L. NANVERS

AGFA

POSTER, C. 1934

ARTIST UNKNOWN

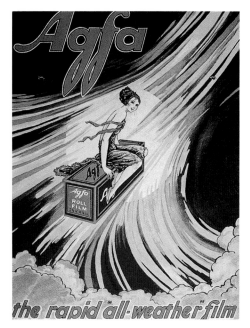

SELO

POSTER, C. 1938

ARTIST UNKNOWN

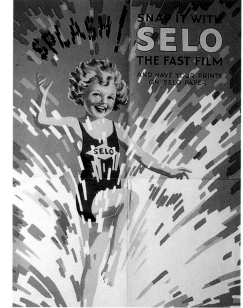

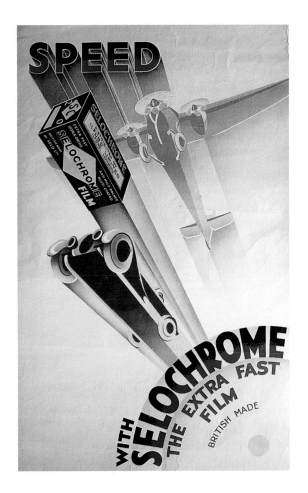

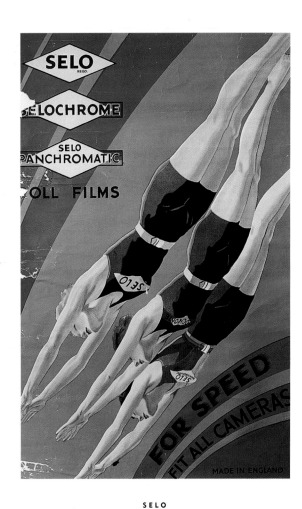

SELOCHROME

ADVERTISEMENT, C. 1938

ARTIST UNKNOWN

LUKOS

PACKAGE, C. 1938

ARTIST UNKNOWN

SELO

ADVERTISEMENT, C. 1935

ARTIST UNKNOWN

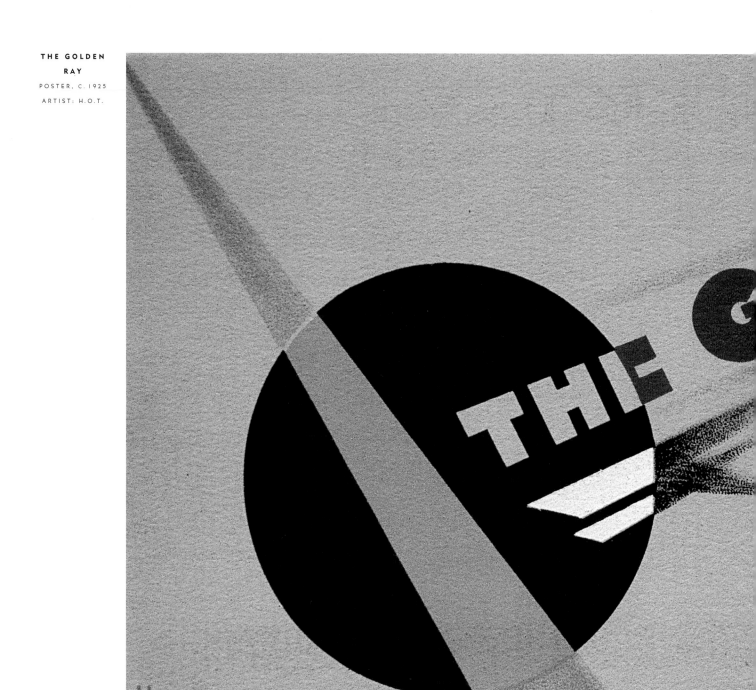

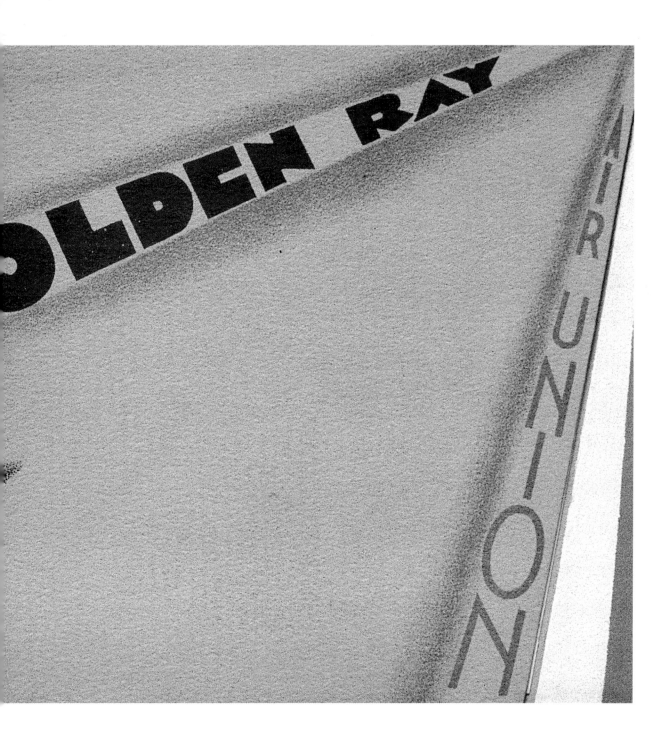

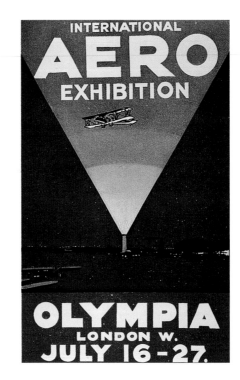

RUDGE FOUR

POSTER, C. 1930

ARTIST: HORACE TAYLOR

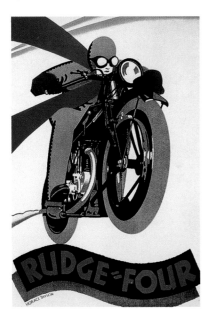

INTERNATIONAL

AERO EXHIBITION

POSTER, C. 1927

ARTIST UNKNOWN

RUDGE FOUR

POSTER, C. 1930

ARTIST UNKNOWN

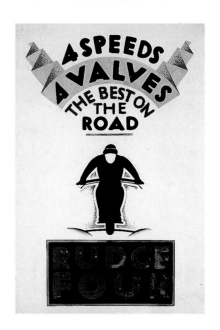

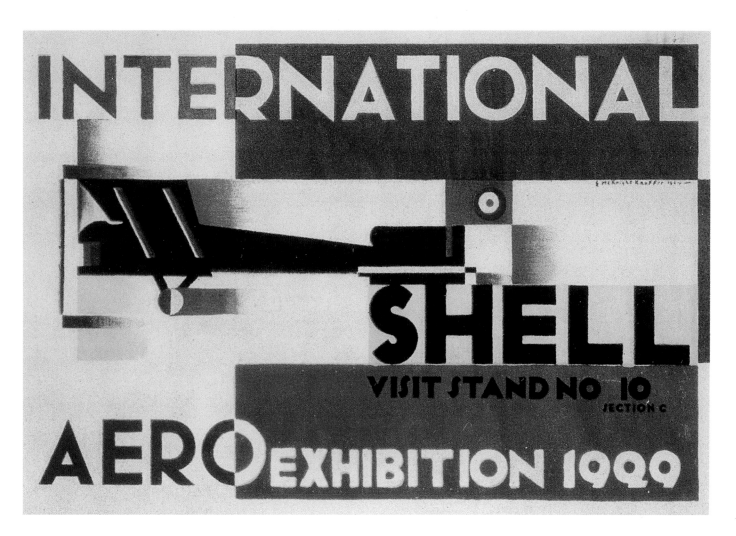

INTERNATIONAL
AERO EXHIBITION
POSTER, 1929
ARTIST: E. MCKNIGHT
KAUFFER

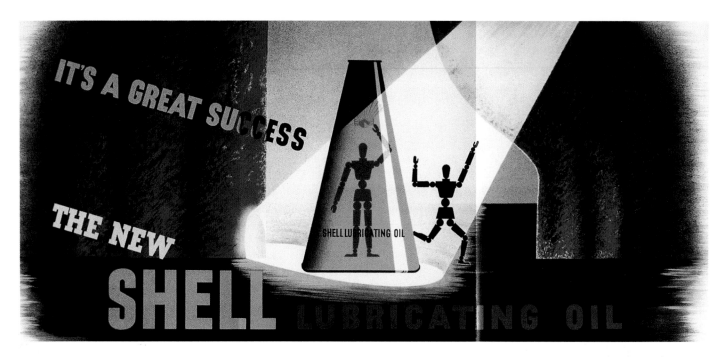

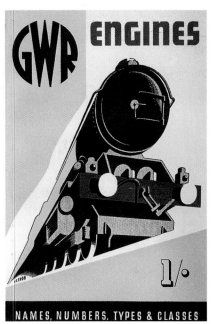

THE NEW SHELL

POSTER, C.1936

ARTIST UNKNOWN

ENGINES

ADVERTISEMENT, C.1935

ARTIST: VARNON

IN A CLASS

BY THEMSELVES

ADVERTISEMENT, C.1935

ARTIST: C.F.H

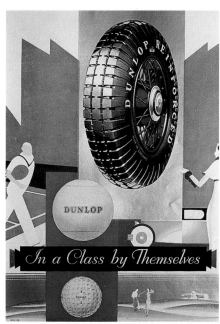

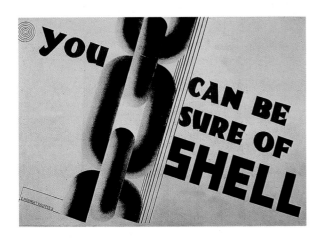

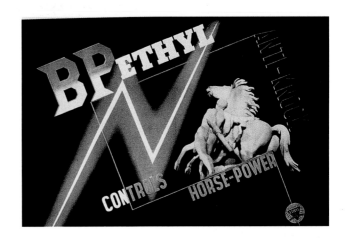

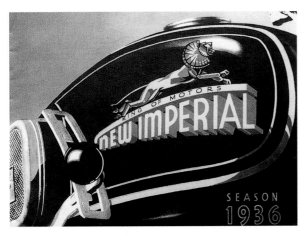

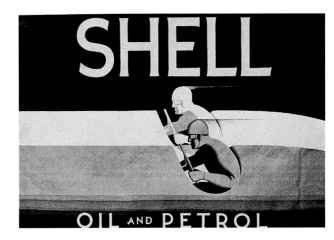

YOU CAN BE
SURE OF SHELL

POSTER, 1931

ARTIST: E. MCKNIGHT

KAUFFER

NEW IMPERIAL

BROCHURE COVER, 1936

ARTIST UNKNOWN

BP ETHYL

POSTER, 1936

ARTIST: E. MCKNIGHT

KAUFFER

SHELL

POSTER, C. 1926

ARTIST: F. C. HARRISON

SUNDRIES

Compared to France's exuberance and Germany's polish, England's package designs for sundries were not really very good. "This is a form of advertising we should do well to develop as the Empire Marketing Board is trying to develop it in connection with its general imperial scheme," wrote Joseph Thorp in *Design in Modern Printing: The Year Book of the Design and Industries Association 1927–28.* "We are a nation of exporters, and it is of primary importance for us to make our goods attractive from the point of view of their ultimate consumers and not from our own We must now make a closer study of taste, remembering that attractive packaging is a strong sales asset." Yet it took some time before this particular design form caught up with the rest of the world's standards. Which is curious, since advertising for sundries—those ubiquitous displays strategically positioned on pharmacy counter-tops—was certainly on a par with other nations' achievements. The fact was that the English con-sumers preferred packages that spoke of tradition. Heraldic decoration and ye olde English ornament were apparently more successful lures than the moderne filigree common to this kind of product. Moreover, England did not have as thriving a cosmetic and toiletry industry as France or Italy (where packages were also quite good). The most popular perfumes were imported from the continent, while fine English-made beauty products were hard to obtain. Given design virtue alone, only razor blade packages stand above the rest. These superb examples of anonymous Lilliputian graphic art made the most of a confined image area, and when seen together (pages 96–97), they become a veritable speci-men sheet of eccentric moderne typography. Otherwise the examples in this chapter appear to be only reluctantly modern and a few are stubbornly mainstream.

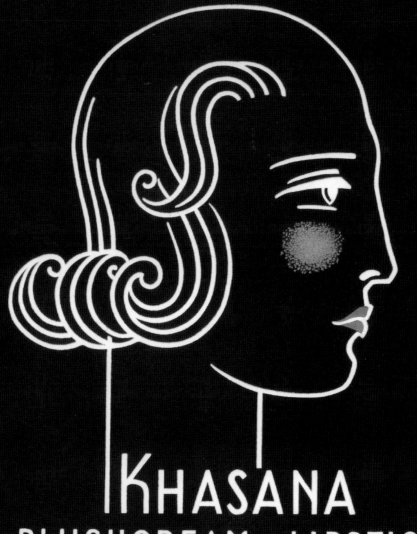

KHASANA
COUNTER
DISPLAY,
C. 1930
ARTIST
UNKNOWN

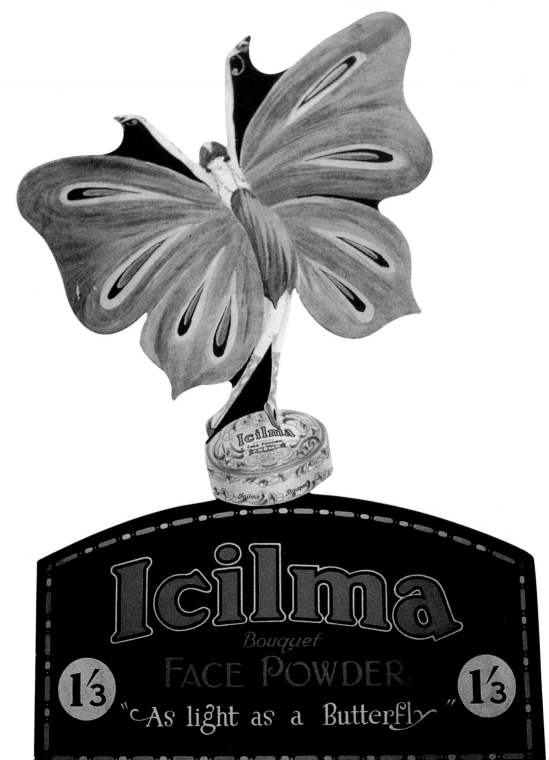

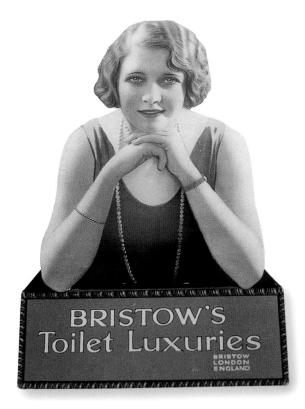

BRISTOW'S

COUNTER DISPLAY,

C. 1925

ARTIST UNKNOWN

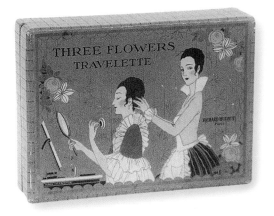

TRAVELETTE

PACKAGE, C. 1925

ARTIST UNKNOWN

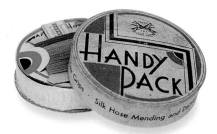

HANDY PACK

TIN, C. 1925

ARTIST UNKNOWN

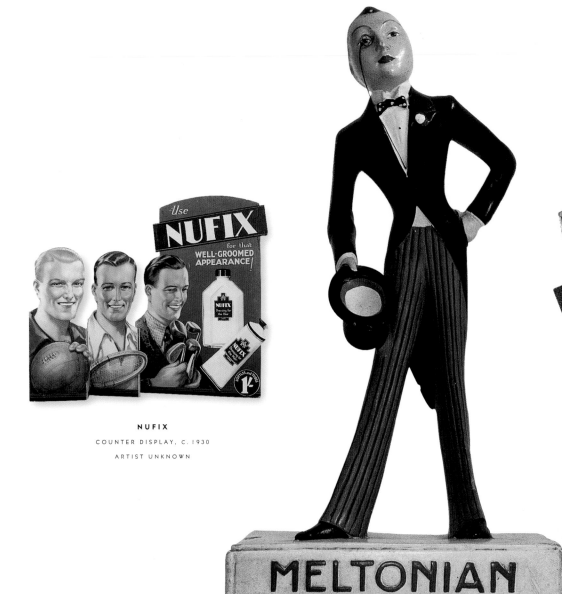

NUFIX

COUNTER DISPLAY, C.1930

ARTIST UNKNOWN

ROLLS RAZOR

COUNTER DISPLAY, C.1928

ARTIST UNKNOWN

MELTONIAN

COUNTER DISPLAY,

C.1930

ARTIST UNKNOWN

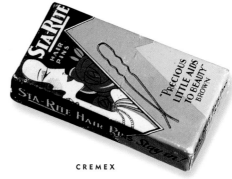

CREMEX

LABEL, 1921

ARTIST: A. ERDMANN

STA-RITE

PACKAGE, C. 1927

ARTIST UNKNOWN

BŪTYWAVE

COUNTER DISPLAY, 1928

ARTIST UNKNOWN

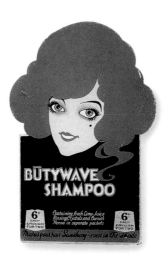

SPECIFIT

ATTA-BOY
RAZOR BLADE

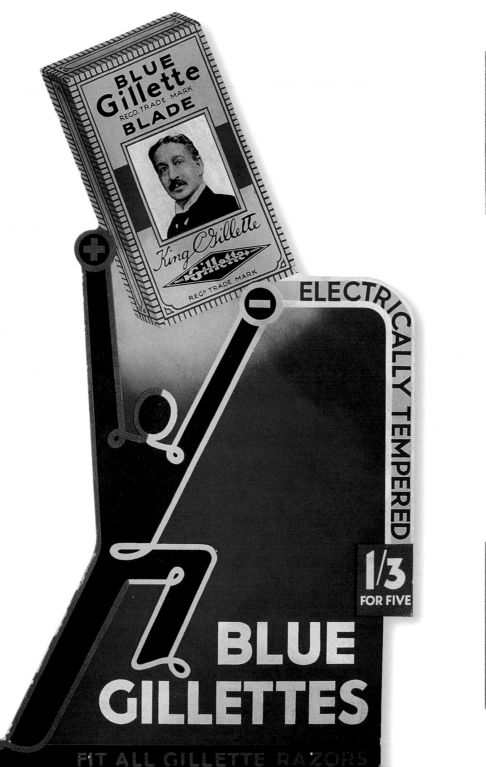

ASSORTED
RAZOR BLADES

1930—1939

ARTISTS UNKNOWN

BLUE GILLETTES

COUNTER DISPLAY,
C. 1933

ARTIST UNKNOWN

The Dandy

EXACTA
RAZOR BLADES

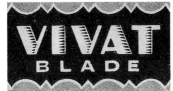
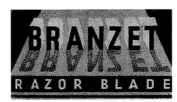

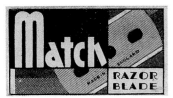

ASSORTED RAZOR BLADES

1930—1939

ARTISTS UNKNOWN

CONSUMABLES

Food, drink, and cigarettes are at once the easiest and hardest products to package. They are staple commodities, and it shouldn't matter how they are designed. But in a competitive marketplace, a superior package or exemplary advertisement can make the difference. During the 1920s little attention was paid to the design of English consumables. Advertising agencies devoted their energies elsewhere, assuming that these products would take care of themselves on the shelves. That is until a generation of brash and eager advertising men decided that this was fertile ground for modern design. "Do we not worship the 'old-established'?" wrote G. H. Saxon Mills in *Commercial Art* (1928). "Do we not fear the new like the plague? And if what I am saying is not true in general, it is more than ever true of the average advertising man, who stamps on any new signs of intelligence in advertising as though they were first outbreaks of a forest fire!" This was typical of the debates that artists for industry were having with entrenched admen who were blind to the force of modern graphics on the buying public. Although this style was more effective in other arenas, food, drink, and cigarettes could residually benefit from its popular appeal. "Advertising must create around the product a personality that did not exist before," Saxon Mills continued. "... Advertising creates the new—out of the old. The *newer*—that is to say *fresher*—an advertising campaign, the better As Keats said of poetry, 'it must surprise by a fine excess.'" With everyday consumables, the advertising profession sought to surprise and educate (or at worst mold) the way the public thought, not only about a particular product, but about modern design in general. And so old methods, such as overly rendered illustration, were rejected. Design on the other hand—incorporating simple symbolism and carried out with scientific use of colours—produced better results.

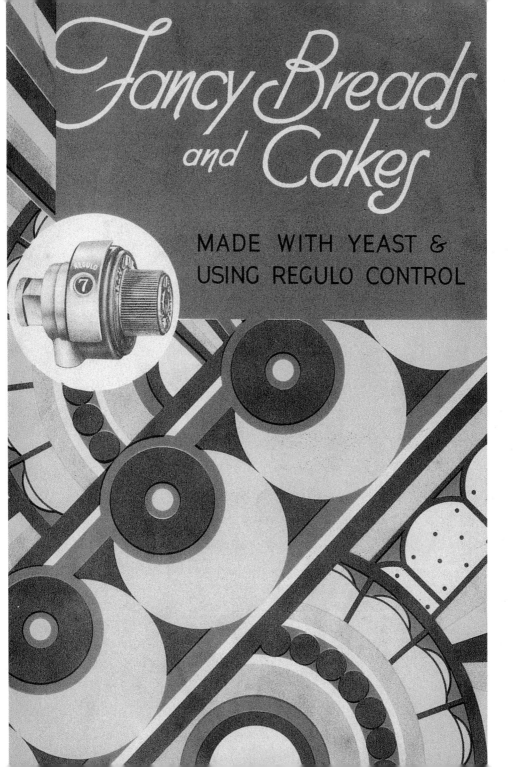

Fancy Breads and Cakes

MADE WITH YEAST & USING REGULO CONTROL

FANCY BREADS AND CAKES
BROCHURE
COVER, 1930
ARTIST UNKNOWN

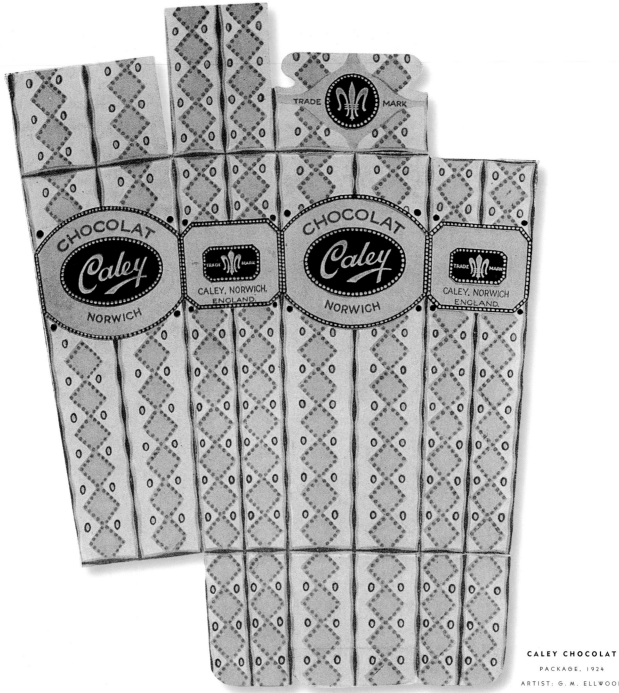

CALEY CHOCOLAT

PACKAGE, 1924

ARTIST: G. M. ELLWOOD

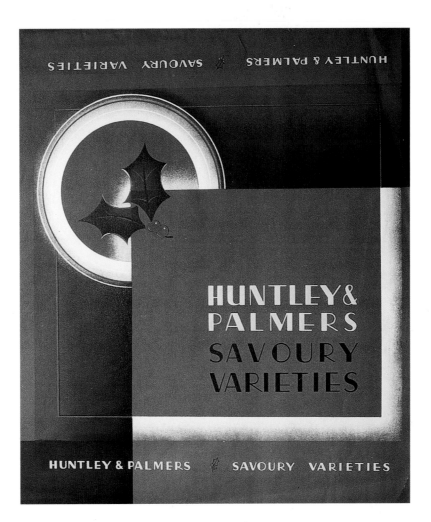

LEMONADE

LABEL, C. 1934

ARTIST UNKNOWN

LEMONADE

LABEL, C. 1934

ARTIST UNKNOWN

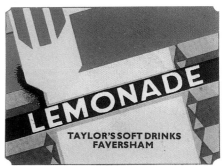

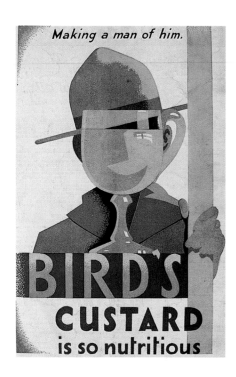

BIRD'S CUSTARD

ADVERTISEMENT, C. 1928

ARTIST UNKNOWN

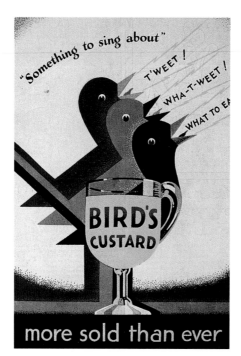

BIRD'S CUSTARD

ADVERTISEMENT, C. 1928

ARTIST UNKNOWN

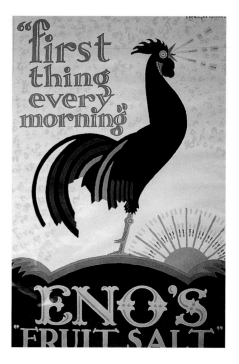

ENO'S

POSTER, 1924

ARTIST: E. MCKNIGHT KAUFFER

"OXO"

TIN, C. 1930

ARTIST UNKNOWN

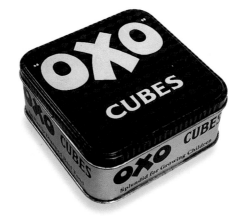

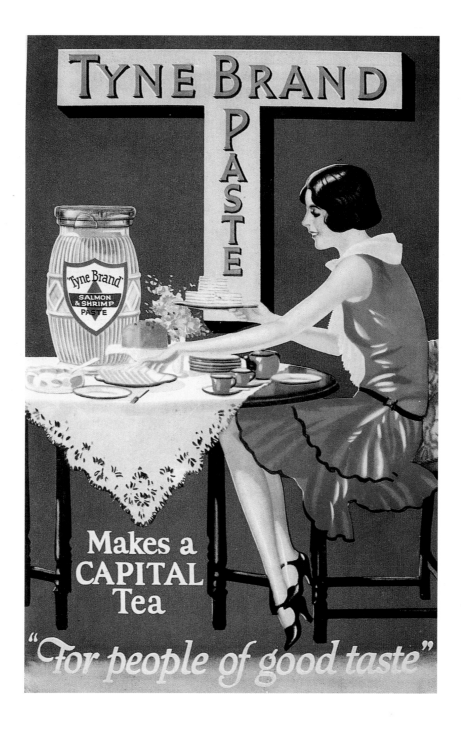

TYNE BRAND PASTE

POSTER, C. 1925

ARTIST UNKNOWN

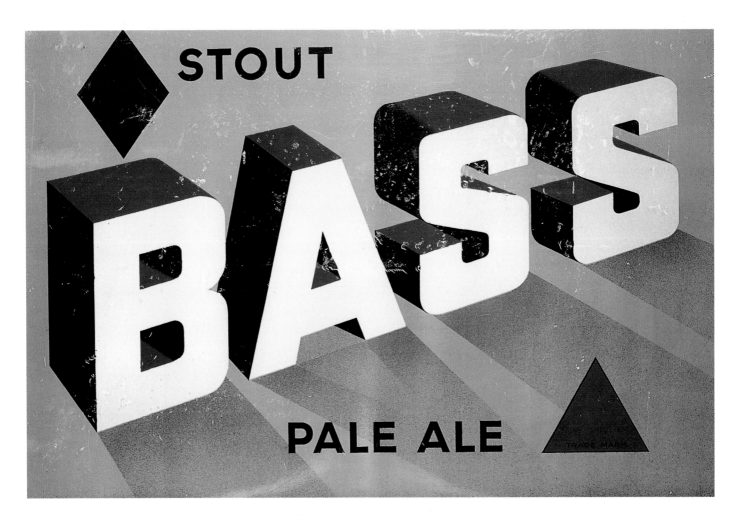

BASS

SIGN, C. 1930

ARTIST UNKNOWN

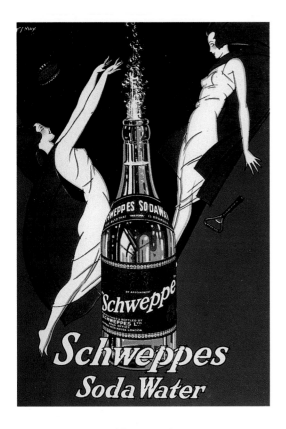

SCHWEPPES

ADVERTISEMENT, 1926

ARTIST: F. S. MAY

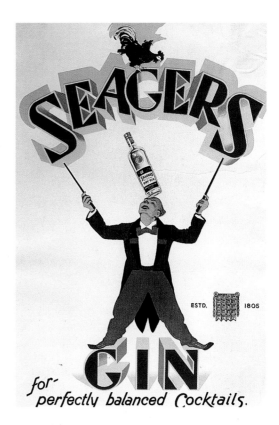

SEAGERS

ADVERTISEMENT, C. 1928

ARTIST UNKNOWN

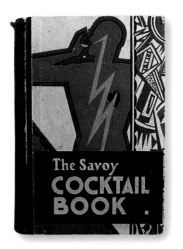

**THE SAVOY
COCKTAIL BOOK**

BOOK COVER, 1930

ARTIST: GILBERT RUMBOLD

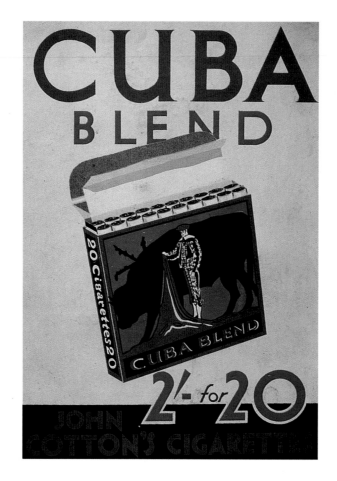

CUBA BLEND

POSTER, C. 1925

ARTIST UNKNOWN

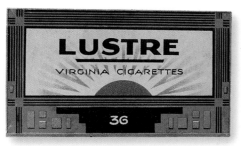

LUSTRE

LABEL, C. 1929

ARTIST UNKNOWN

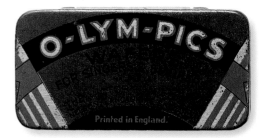

O-LYM-PICS

TIN, 1924

ARTIST UNKNOWN

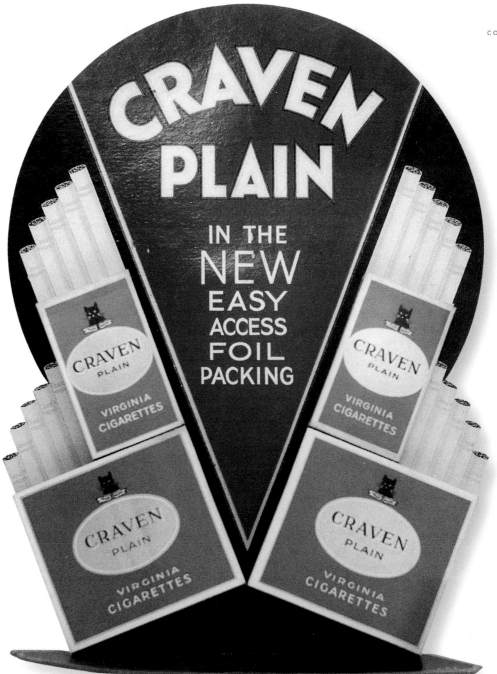

FURNISHINGS

"Ornament should arise out of and be subservient to construction. The true office of ornament is the decoration of utility. Ornament, therefore, ought always to be secondary to utility. True ornament does not consist in the mere imitation of natural objects …," stated South Kensington's *General Principles of Instruction in the Decorative Arts* (c. 1919), a governing document for all English design schools. And so the modern ethos was introduced early into academic institutions that prepared designers and craftsmen to create English furnishings for home and export trade. In fact, as Carol Hogben notes in *British Art and Design 1900–1960*, "All the rules enunciated were astonishingly specific, and founded upon deep practical experience. Some anticipate that functionalist approach that was, through the Bauhaus, to characterize the modern movement in the 20th century …. In essence however, they were a kit of tools equipping students to historicize with taste." English modernism in this arena was a blend of Bauhausian austerity and Arts and Crafts heritage. When it came to advertising furnishings, this hybrid graphic style wed the rectilinear geometry characteristic of the modern movement with a simplified ornamentation that carried on the English penchant for decoration. Although some designers had become ideologically principled regarding the rightness of form, the English public was not apt to rush out to buy home furnishings that were uncomfortable to look at or live with. The graphics that promoted these products had to balance between progress and acceptability. While some of the designs in this chapter appear to be influenced by avant-garde preferences for kineticism and repetition, few extend beyond the taste of the average consumer. Even the most modern or abstract design conceit (see "The Art of Furnishing" on page 111) is tempered by soothing colors and pleasing composition.

CRESCENT

CAN, 1928

ARTIST UNKNOWN

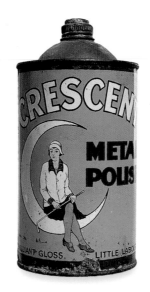

WOOD

PRESERVING STAIN

POSTER, C. 1928

ARTIST: J. H. R.

MANSION POLISH

DISPLAY CARD, C. 1927

ARTIST UNKNOWN

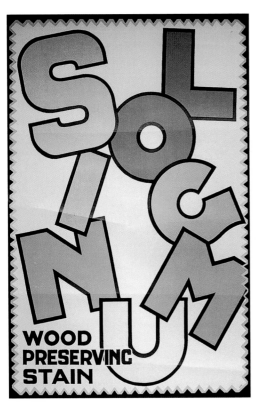

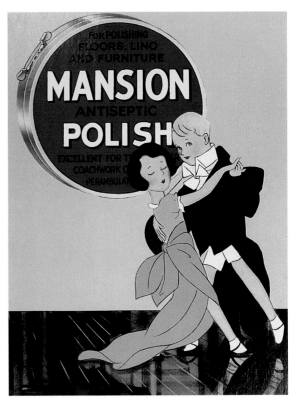

BETTER
FURNITURE FOR
BETTER TIMES
BROCHURE
COVER, 1934
ARTIST: A. F. W.

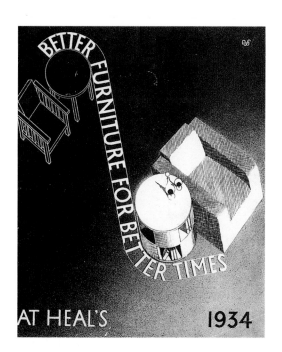

FASHION
FITTINGS
BROCHURE
COVER, C. 1936
ARTIST UNKNOWN

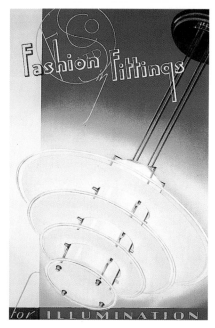

THE ART
OF FURNISHING
BROCHURE, 1932
ARTIST: LEE-ELLIOTT

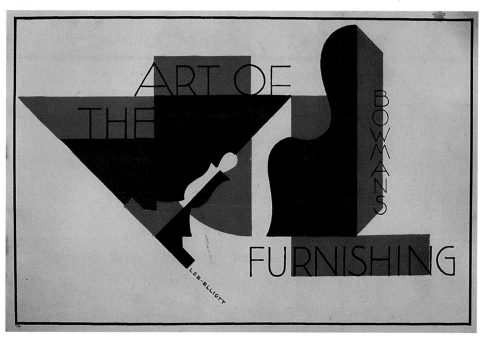

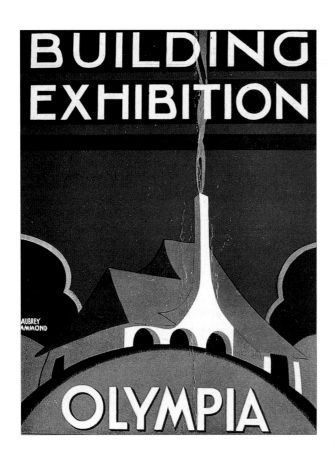

BUILDING EXHIBITION

POSTER, 1930

ARTIST: AUBREY HAMMOND

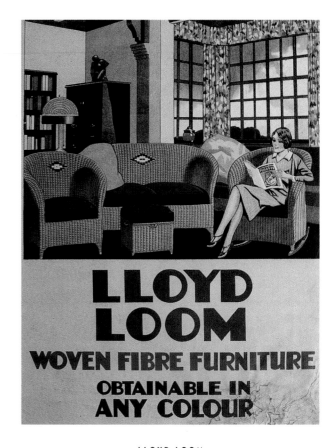

LLOYD LOOM

POSTER, C. 1930

ARTIST UNKNOWN

UNTITLED

PACKAGE, C. 1930

ARTIST UNKNOWN

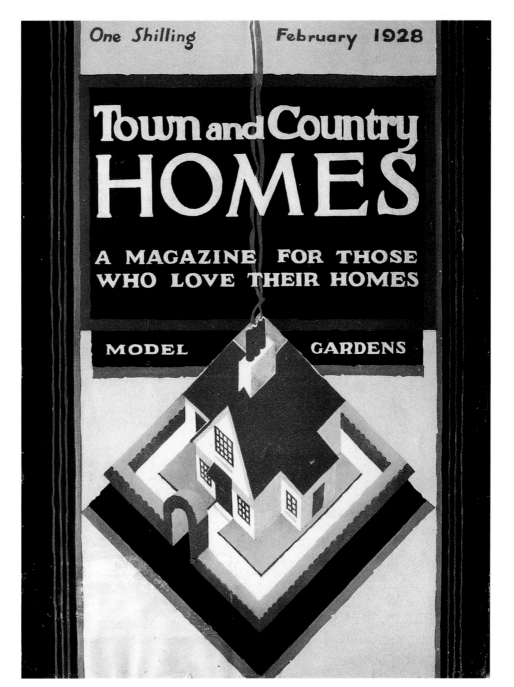

One Shilling February 1928

Town and Country HOMES

A MAGAZINE FOR THOSE WHO LOVE THEIR HOMES

MODEL GARDENS

TOWN AND
COUNTRY HOMES
MAGAZINE
COVER, 1928
ARTIST UNKNOWN

HOLIDAY

By the late 1920s England was considered on the Continent and in America to have the best travel posters. During those years a brilliant crop of posters had been produced by the various railway companies. But as Joseph Thorp noted in *Design in Modern Printing: The Year Book of the Design and Industries Association 1927–28*: "These are, it should be mentioned, posters only in a special sense, for they require detailed perusal usually, as for instance when one is waiting for a train: nevertheless it may well be maintained that this is a form of outdoor publicity in which we beat every other country in the world." Why did Britain reach such heights during an era when Europe was in the vanguard? As Thorp explained: "The Englishman, by necessity a town dweller, is by nature a traveler. His holidays are the focusing point of his year—in which his craving for the sea, the open country, and places to which he is not accustomed can find brief but full satisfaction." So given this propensity for taking satisfying holidays, it became critical for the travel business to employ the most arresting advertising possible. For many previous years these posters relied on images featuring getaways that were realistically rendered with the skill of the academic painter. But with the advent of modernism, new approaches were more quickly adopted. About this transformation a critic wrote in *Commercial Art* (1928): "The last year confirms one's opinion that flat brilliant colours and flat masses that are at once decorative in themselves and descriptive of the scene are the best for the poster. The academic experiments that have been tried from time to time have failed and the artist with the special poster technique—like Tom Purvis—wins the day. Comparison with the average French travel poster shows an enormous superiority in England, curious in view of the general artistic relations of the two countries."

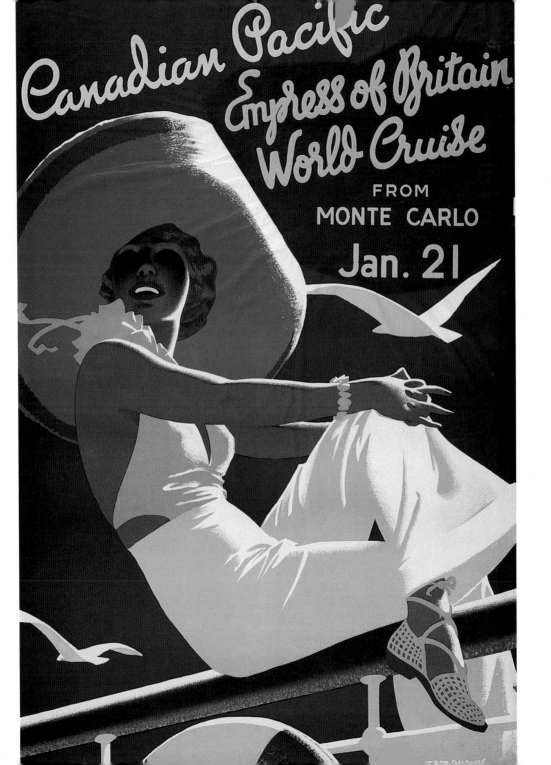

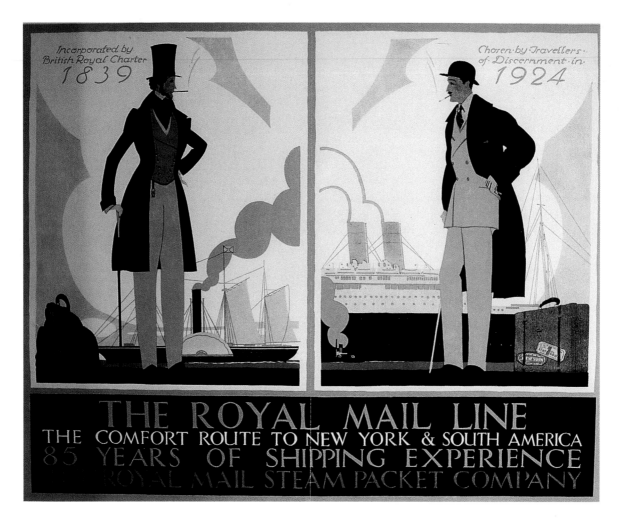

Incorporated by
British Royal Charter
1839

Chosen by Travellers
of Discernment in
1924

THE ROYAL MAIL LINE
THE COMFORT ROUTE TO NEW YORK & SOUTH AMERICA
85 YEARS OF SHIPPING EXPERIENCE
ROYAL MAIL STEAM PACKET COMPANY

THE ROYAL MAIL LINE

POSTER, 1925

ARTIST UNKNOWN

BLUE
FUNNEL
LINE

GREAT BRITAIN — AUSTRALIA

BLUE FUNNEL LINE

LOGO, C. 1924

ARTIST UNKNOWN

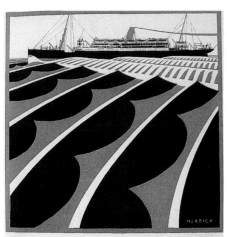

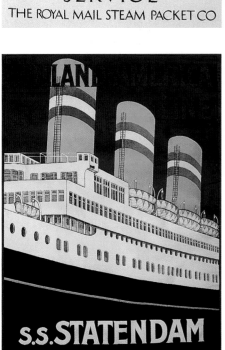

R·M·S·P

POSTER, 1927

ARTIST: HERRICK

**LIVERPOOL
AND DUBLIN**

BROCHURE, C.1926

ARTIST: H.R.

S.S. STATENDAM

POSTER, C.1927

ARTIST UNKNOWN

NELSON LINES

BROCHURE, C.1927

ARTIST UNKNOWN

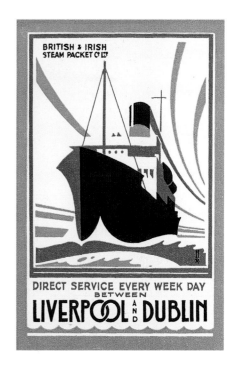

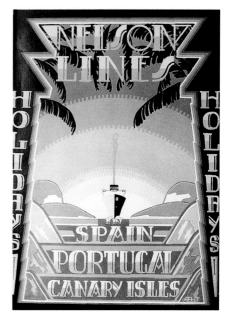

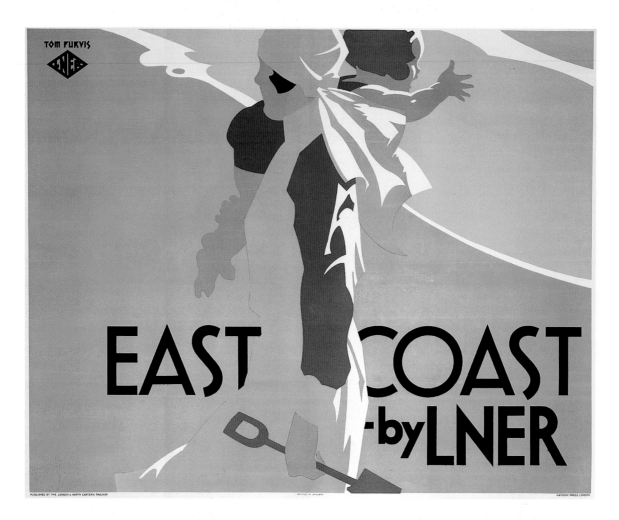

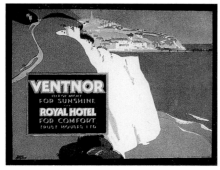

EAST COAST

POSTER, C. 1930

ARTIST: TOM PURVIS

VENTNOR

POSTER, C. 1930

ARTIST: FRANK NUBOULD

HARROGATE

POSTER, 1923

ARTIST: TOM PURVIS

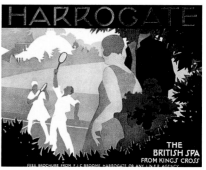

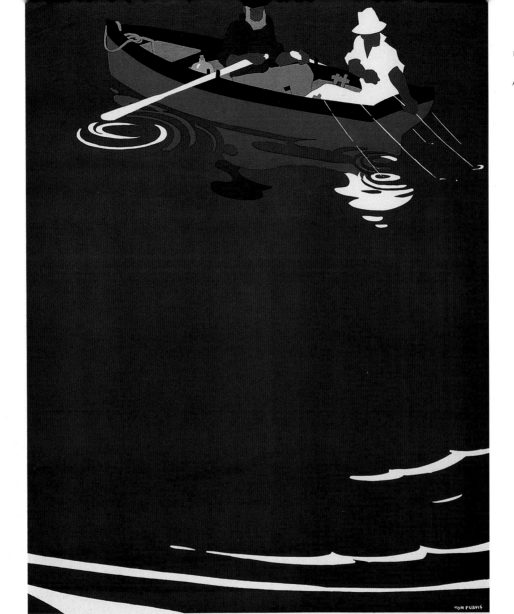

Nº 5 SEA FISHING

EAST COAST JOYS
travel by L·N·E·R
TO THE DRIER SIDE OF BRITAIN

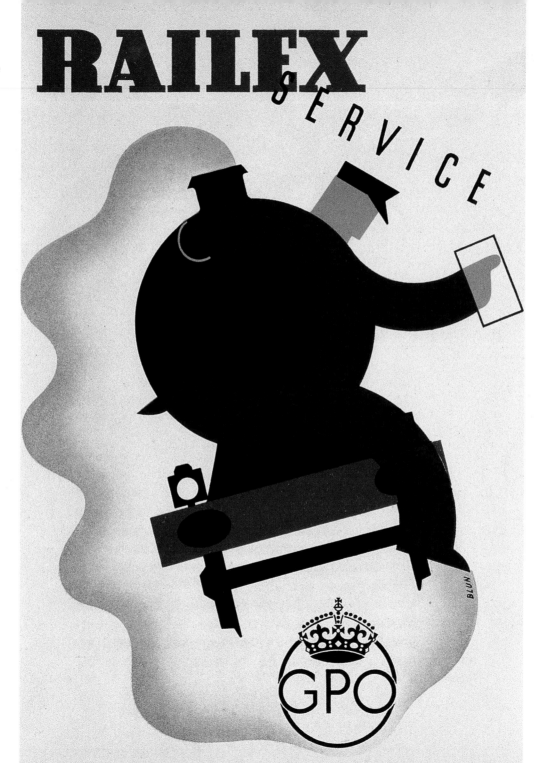

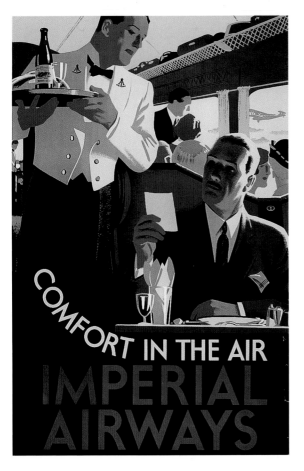

COMFORT IN THE AIR

POSTER, C. 1935

ARTIST: TOM PURVIS

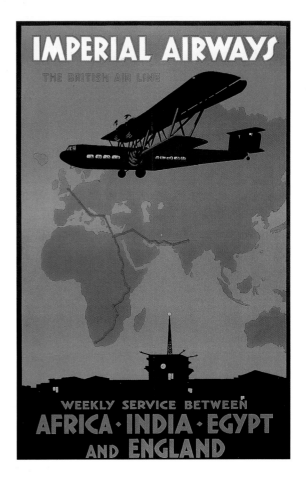

IMPERIAL AIRWAYS

POSTER, C. 1924

ARTIST UNKNOWN

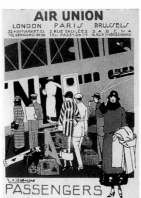

AIR UNION

POSTER, C. 1927

ARTIST: J. C. BALLAIQUE

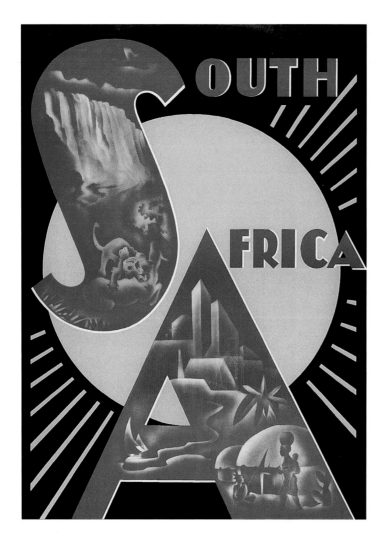

SOUTH AFRICA

POSTER, C. 1930

ARTIST: ULLMANN

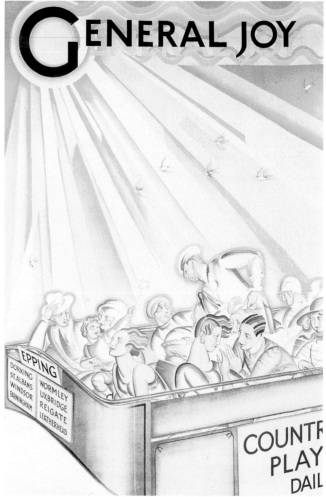

GENERAL JOY

POSTER, C. 1925

ARTIST UNKNOWN

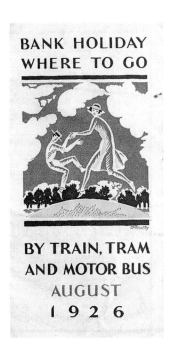

**BANK HOLIDAY
WHERE TO GO**

POSTER, 1926

ARTIST: M. BATTY

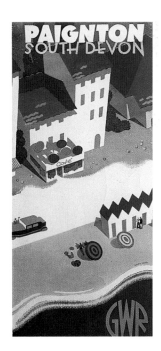

PAIGNTON

POSTER, C. 1928

ARTIST: RALPH MOTT

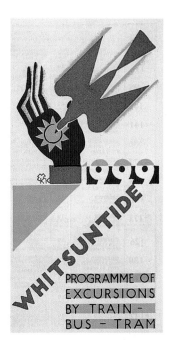

WHITSUNTIDE

POSTER, 1929

ARTIST: E. MCKNIGHT
KAUFFER

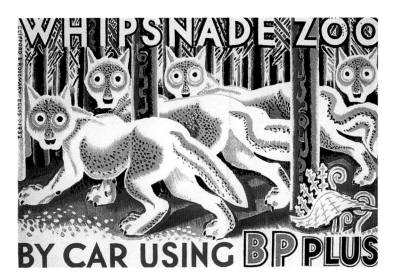

WHIPSNADE ZOO

POSTER, 1932

ARTIST: CLIFFORD AND
ROSEMARY ELLIS

TYPOGRAPHY

Every nation has a national symbol; some even have their own typeface. Although not officially designated as such, two faces of the 1920s and 1930s are inextricably English. One is Edward Johnston's block letter designed for the Underground, which caused consternation among typographers when it first appeared in 1916. "It was a breathtaking surprise to nearly all who could be interested," wrote Noel Rooke (quoted in *Edward Johnston* by Priscilla Johnston, Pentalic Corporation, NY, 1976), "the very lowest category of letter had been suddenly lifted to a place among the highest." The other was the sans-serif caps designed in 1928 by Eric Gill. Originally Johnston and Gill were hired to work together on the Underground face. Gill dropped out only to revisit the modern sans-serif years later when he was commissioned by Lanston Monotype Coporation to create a new alphabet. Gill's type caused a "storm of excitement," according to Beatrice Warde in *Advertising Display* (1928), because gothics belonged to an "abhorred family of type." The precisionist quality of Gill Sans challenged the archaism of most diehard traditionalists. Nevertheless, English typography critics warned against novelty for its own sake: "Our job in letter designing is not to give free reins to our invention, but to keep it well within the bounds of the established shapes of those signals called letters," exhorted Joseph Thorp, who attacked so-called "original" designers of type who filled the specimen books of the 1920s. He argued that originality consisted in departing as far as possible from the established convention by "the addition of nicks and bulges and slopes, the heightening or lowering of cross-strokes, the backward or forward sloping of the axis of the 'counters'—a practice developed to a distressing extent."

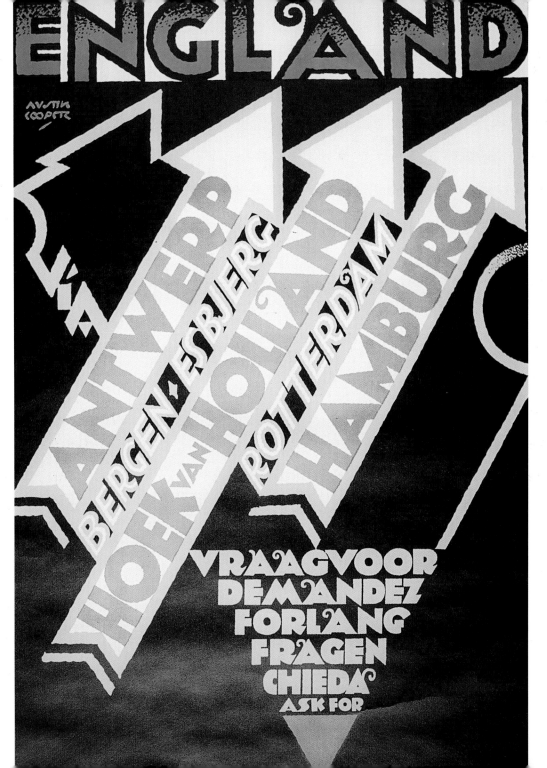

ENGLAND
POSTER, 1928
ARTIST:
AUSTIN COOPER

BLACK AND
WHITE
BOOK JACKET,
C. 1923
ARTIST:
A. ERDMANN

ASHLEY CRAWFORD PLAIN

GILL CAMEO RULED

MODERN

BRAGGADOCIO

Modern

LIGHT SCRIPT

MODERN

GILL SANSERIF SHADOW

MODERN

OTHELLO

MODERN

ROCKWELL SHADOW

MODERN

GROCK

OPPOSITE:

THE BRILLIANT SIGN CO.

SIGNS, C. 1925

ARTISTS UNKNOWN

128

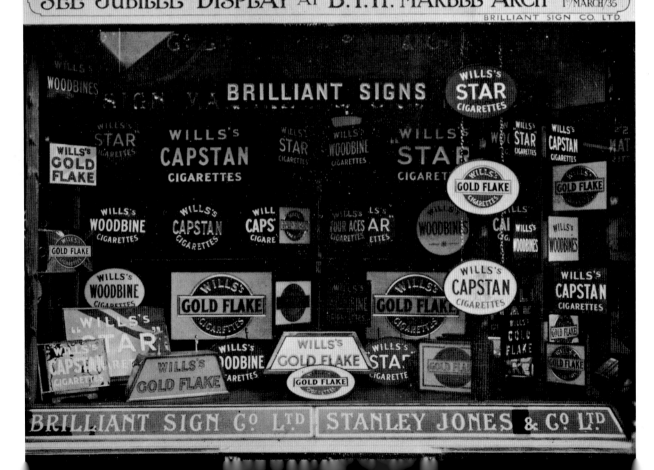

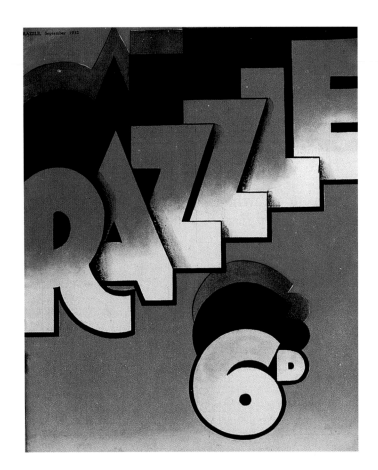

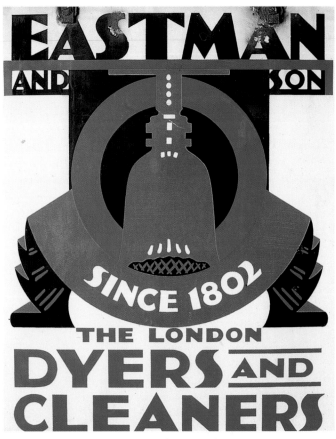

RAZZLE

MAGAZINE COVER, 1932

ARTIST UNKNOWN

EASTMAN AND SON

ENAMEL SIGN, C. 1926

ARTIST UNKNOWN

PARK DRIVE

COUNTER DISPLAY, C. 1927

ARTIST UNKNOWN

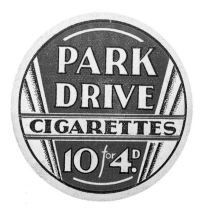

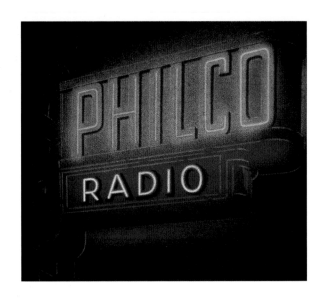

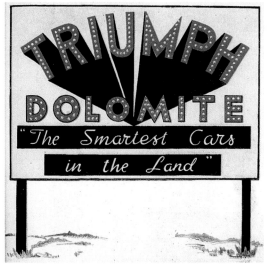

PHILCO RADIO

NEON SIGN, C. 1930

ARTIST UNKNOWN

TRIUMPH

SIGN, C. 1930

ARTIST UNKNOWN

PERMS

NEON SIGN, C. 1930

ARTIST UNKNOWN

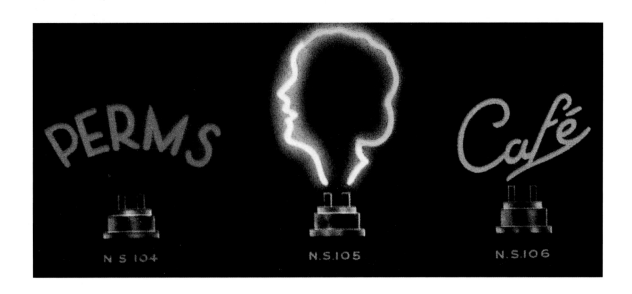

BIBLIOGRAPHY

Advertising Display. Volume V Number 1. July 1928.

Advertising Display. Volume V Number 2. August 1929.

Campbell, Colin. *The Beggarstaff Posters: The Work of James Pryde and William Nicholson*. Barrie & Jenkins, London. 1990.

Commercial Art. Volume 3. 1927.

Commercial Art. Volume 5 Number 26. 1928.

Commercial Art. Volume 7 Number 39. 1929.

Commercial Art and Industry. May 1935.

Fishenden, R.B., editor. *Penrose Annual*. Percy Lund Humphries & Co. Ltd., London. 1935.

Gill, Eric. *An Essay on Typography*. David R. Godine, Boston. 1988.

Green, Oliver. *Art for the London Underground*. Rizzoli, New York. 1990.

Harrison, John, editor. *Posters and Publicity: Fine Printing and Design*. The Studio, Ltd., London. 1927.

Hogben, Carol. *British Art and Design 1900–1960*. Victoria and Albert Museum, London. 1983.

Holme, C.G., editor. *Lettering of To-Day*. The Studio Limited, London. 1937.

International Printing 1. Jarrold & Sons, Limited, Norwich. 1947.

Johnston, Pricilla. *Edward Johnston*. Pentalic Corporation, NY, 1976.

Thorp, Joseph, editor. *Design in Modern Printing: The Year Book of the Design and Industries Association 1927–28*. Ernest Benn Limited, London. 1928.